celtic spirals
and other
designs

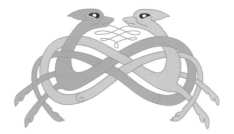

CELTIC SPIRALS AND OTHER DESIGNS

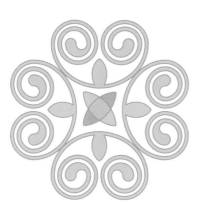

Sheila Sturrock

GUILD OF MASTER CRAFTSMAN PUBLICATIONS LTD

First published 2000 by
Guild of Master Craftsman Publications Ltd,
166 High Street, Lewes,
East Sussex, BN7 1XU

Photographs by Jack Swindlehurst
Illustrations produced by Simon Rodway,
based on work by Sheila Sturrock

ISBN 1 86108 159 6
A catalogue record of this book is available from the British Library

Designed by Wheelhouse Design
Cover by Wheelhouse Design
Typefaces: Sabon, Omnia, Cantoria MT

Colour origination by Viscan Graphics (Singapore)
Printed and bound by Kyodo Printing (Singapore) under the
supervision of MRM Graphics, Winslow, Buckinghamshire, UK

Contents

❖

Acknowledgements

◆

Thankyou to the following people who so generously gave their time to work examples and to write about their crafts: Maureen Bowe, appliqué; Elaine Craddock, batik; Pauline Stone, bobbin lace; Mary Heap, calligraphy (illumination); Val Fynan, calligraphy (texts); Kate Haines, cross stitch and quilting; Eileen Charnock, fabric painting; Christine Sunderland, hardanger embroidery; John Sturrock, knitting; Jackie Cardy, machine embroidery; Karen Quickfall, needlepoint lace brooch; Dianne Derbyshire, needlepoint lace jewellery; Bernice Howarth, pastel drawing; Norma Gregory, pyrography; Susan Lord, quilling; Joyce Law, watercolour; Moray Sturrock, squared chart. [Tatted motif by Sheila Sturrock.]

INTRODUCTION

In my previous book, *Celtic Knotwork Designs*, every section apart from the last, which used only straight lines, contained designs developed directly from some form of loop. It occurred to me that every design containing loops could be accurately plotted using the classic pelta as a base. The pelta is an ideal mathematical instrument, easily constructed, easily transported, simple to use and eliminating any need for complicated calculations when plotting designs: it would be a useful instrument for stone carvers, woodcarvers and others working on particularly large-scale pieces.

Accurate, repeating designs can be set out even by inexperienced workers using the pelta as a template for drawing circles, hearts and loops which can then be connected by lines.

Spirals are less complicated, and easier to understand, than interwoven knotwork designs, and even a single ribbon can create an effective border pattern.

Spirals were the earliest motif used for decoration in Celtic art and from them developed the fret, maze and key patterns. The designs in this book have been arranged so that they commence with a simple loop and develop into more complex (but no more difficult) patterns. The next section of the book includes pelta and spiral designs, both constructed from circles, and uses circles to plot interwoven ribbons. The spiral is then replaced with a square and the s- and c-curves used for joining motifs are replaced with straight lines to construct maze, key and fret patterns. The zoomorphs are placed in a section of their own.

The designs in this book are plotted by first positioning a series of circles and then connecting these with s- and c-curves to indicate the location of the exit points for the ribbons, before converting the circles to spirals. Effective designs are drawn by varying the size of the circles. The spirals are constructed by theoretically 'sliding' the circles apart. This opens the circles up, creating free ends which can then be linked at different points, and in various ways, to create spirals. A simple method for drafting this is given in Chapter 3.

The spaces outside spirals can be filled in several ways. One of the traditional embellishments is a stylized leaf design, but there are many others, including zoomorphic heads, shading, graining, basketweave lines . . . Examples of all of these are given in Chapter 19.

'... if you take the trouble to look very closely, and penetrate with your eyes to the secrets of the artistry, you will notice such intricacies, so delicate and subtle, so close together and well-knitted, so involved and bound together, and so fresh still in their colourings that you will not hesitate to declare that all the things must have been the result of the work, not of men, but of angels.'

Giraldus Cambrensis
(twelfth century)

PART ONE

History & Equipment

Chapter 1

HISTORY

✦

The Celts

During the seventh century BC, Celts from the Continent began to arrive and settle in Britain. Celtic kings were often patrons of the arts, and the Celts are still known for their art, fine ornaments and jewellery.

Celtic art was both decorative and religious, borne from the oral traditions of the Celtic people and the beliefs they learned from the Druids. It had three main functions:

✦ depiction of stories;
✦ decoration; and
✦ religious symbolism.

According to Celtic beliefs, there are seven created life forms – plant, insect, fish, reptile, bird, mammal and man. These are all represented in Celtic art, but in a stylized and highly imaginative form, as to copy the art of the creator was forbidden. Human figures (anthropomorphics) depict men with interlaced limbs and extended beards, and animal forms (zoomorphics) are shown with extended and interweaving ears, tails and tongues.

The Celtic school of art

Celtic designs can be classified as either rectilinear or curvilinear. Rectilinear designs include Greek key patterns, fret, step or maze patterns, and key patterns which are a modification of fret patterns, using diagonal lines. Curvilinear designs include spirals and interlaced knotwork.

Fig 1.1 A simple, single-line spiral pattern

Fig 1.2 A Greek key pattern

Spirals and other early designs

Early forms of decoration were simple, restricted to lines, crosses and circles. They were based on observations of the patterns formed by solar and lunar phenomena that were prevalent in the northern hemisphere, so, a cross represented the four winds, the four seasons, the four cardinal points, and the sun.

By adding lines at 90° to the arms, a sense of movement was given to the basic cross design. This design, known as the swastika, is one of the most common designs of the ancient world. It was used as a sign of good augury and benediction and, though not generally known, it was adopted by the Christian Church. While not much used as a symbol today, it is accepted as a satisfactory sculptural design which signifies benediction. The

word 'swastika' is derived from the Sanskrit 'svastika', itself from 'svasti', meaning prosperity: it was believed that the symbol would bring good luck.

Fig 1.3 The basic swastika

The triskele, a three-legged swastika, is a sun symbol from the Bronze Age. It first appeared around 1500BC and today is recognized as the symbol for the Isle of Man. ('Triskele' is derived from the Greek 'tri' and 'skelos' meaning 'three legs'.) Spiral patterns were developed from the swastika and the triskele, and both designs are to be found in all lands occupied by Celts.

Fig 1.4 The basic triskele

Another common symbol was the wheel, whose spokes represented the sun's rays. There are numerous forms of the wheel, and many instances of wheels being buried in graves to illuminate the journey of the deceased to the afterlife. Scandinavian rock carvings dating from c.1500BC show examples of quarter-circle wheels.

Between 3000 and 1500BC, the Egyptians used spiral designs to decorate the ceilings of tombs. Some were set out as diapers (all-over patterns) and others as border designs. Colour was important in these ceiling decorations – only red, yellow, blue, green, black and white were used, alternated for variety. Plant motifs, interlocking spirals and flattened scrolls were often incorporated, scrolls were used to border signs of particular symbolic importance, and concentric circles were used to decorate seals.

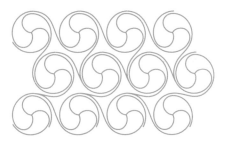

Fig 1.5 An all-over design of single circles with three exit points

Fig 1.6 A border of single-circle spirals with two exit points

The spiral motif was introduced to Scotland and northern Britain from Scandinavia, where many fine examples, including decorated sword hilts, are on display in museums. From here, they travelled to Ireland; the stone monuments

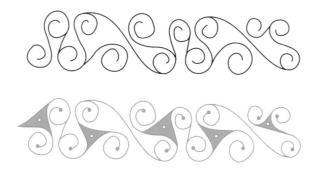

Fig 1.7 These two examples of Celtic spirals have the same design, but one has additional decoration

in this country display some of the best examples of closely coiled spirals and borders of interlaced work, including scroll patterns.

The Celts became skilled at developing new arrangements of spirals and also at methods of producing two or more ribbons from the centre of a circle. Producing multiple ribbons meant that they could be intertwined. Ribbons were sometimes 'closed' with a zoomorphic embellishment, or extended around other spirals to give the appearance of a continuous pattern.

Scandinavian Bronze Age artefacts are decorated mainly with evenly spaced spirals that are joined with an arc that is either an s- or a c-shaped curve. In nature, for example, the nautilus shell, most spirals rotate in a clockwise direction, but Celtic spirals rotate in alternating directions. This alternation gives a sense of balance which is the main feature of Celtic design.

In later Celtic designs the spirals are placed further apart and joined by long, tapering curves. Known as trumpet

Fig 1.8 In this design, the ends of the spirals are taken around an adjacent spiral, and joined to the rim of an outer circle

Fig 1.9 A simple border of spiral swastikas

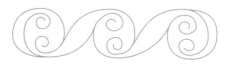

Fig 1.10 S-curves enclose these spirals into a solid motif

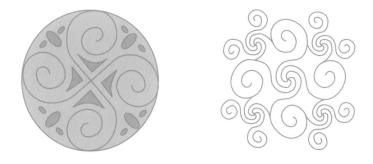

Fig 1.11 These motif variations combine two-exit spirals with a four-exit centre

spirals, these are so-called because the two lines leaving the centre of the motif travel apart, thus forming a wide curve similar to the mouth of a trumpet. These two lines then travel back to meet each other before parting again. This produces a pattern of spirals and graceful curves; spaces in these patterns are often filled with colour or additional decoration. Originating in Crete, the trumpet spiral arrived in Britain in the Bronze Age and was adopted by Celts for decorating jewellery and other ornamental objects. Examples can be found on late Celtic work in Britain, dating from 200BC–200AD.

The earliest motif used for decoration in Celtic Christian art, the spiral was also the first to disappear, in the early part of the tenth century.

Materials

Spiral designs were used mainly in the decoration of jewellery and other objects and as such were enamelled rather than coloured with paints and ink. Many early spiral designs were carved on stone and would not have been coloured at all.

However, there are examples of spirals in the major Celtic texts, for example, the *Book of Kells* and *The Lindisfarne Gospels*, and the discussion below relates to the materials used in such illuminated manuscripts.

These manuscripts were created using simple materials. Lines were drawn with the quill of a goose or crow feather, both of which could be fashioned to give a square end with a very fine point, and the designs were then scored using a stylus made from wood, iron or bone. (It is possible that silver points were also used.) Vellum was used for manuscripts. The difficulties of writing on a hairy surface such as this were overcome by the fineness and shape of the quill point.

Writing on a hairy surface is rather like drawing with pen on a pile carpet. The square end of the quill allowed it to travel down through the vellum pile which enabled the scribe to draw on the actual skin rather than on the fine fibres.

With the design plotted, further details were superimposed in light-coloured ink. Colour was applied to the edges with a

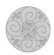
quill, and large areas were coloured using a brush. Designs were sometimes highlighted by leaving small areas of the work unpainted.

Colours

Celtic artists had an astonishing knowledge of the chemical properties of pigments and their manuscripts were alive with vibrant colour. This quote from the venerable Bede, writing in the early eighth century (*Ecclesiastical History of the English People*, Book 1, Chapter 1), refers to the brilliance of the red used in Irish illuminations:

'There is also a great abundance of cockles, of which the scarlet colour is made; a most beautiful colour, which never fades with the heat of the sun or the washing of the rain, but the older it is, the more beautiful it becomes'.

Many pigments were obtained from local sources: red from red lead; yellow (orpiment) from soil found in parts of Ireland; emerald green from copper; violet blue from the woad plant (also known as 'dyer's weed'); whites from white lead and chalk; and verdigris, a greenish-blue from a patina formed on copper, brass or bronze. Other pigments were imported: mauves, maroons and purples are thought to have been obtained from the Mediterranean plant *Crozophora tinctoria*; kermes (crimson) was produced from the pregnant bodies of insects (*Kermococcus vermilio*) that lived in the evergreen trees of the Mediterranean; and ultramarine, a rare and valuable pigment of brilliant blue, thought to have been obtained by crushing lapis lazuli, which was imported from the foothills of the Himalayas in north-east Afghanistan. Indigo, an oriental plant, was the source of a deeper blue.

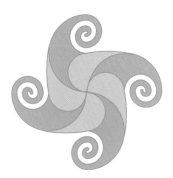

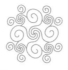

Chapter 2

Materials & Equipment

The materials required for drawing Celtic spirals are few and inexpensive.

Plotting

Graph paper is essential for plotting fret, key and maze patterns and is also useful for setting out spiral designs. You can experiment with different layouts using a circle template on graph paper. I recommend 5mm squares as a convenient size for trying out most patterns. It is also helpful to try out different arrangements for designs using lay-out paper.

Grids can easily be transferred from graph paper to plain paper by securing a plain sheet over the graph paper with masking tape, and using the squares to

draw a grid on the plain sheet (see Fig 2.1). A useful item for plotting spiral patterns is a circle template. A standard template, available from most stationers, has a large selection of sizes ranging from 3–30mm (⅛–1¼in), and larger templates are available from drawing office supplies. Templates are used to try out different arrangements of circles and to identify where the exit points will be before converting them to spirals.

Tracing paper is very useful in helping to identify the paths of the lines in a spiral. It can be difficult to follow the paths of two or more lines so, before filling in a complex design, trace along each line in a different colour to clearly identify their paths and to decide which colours to use to fill in the enclosed spaces.

Lay-out paper is ideal for designing zoomorphics, helping to identify the connection points of borders and to modify loops and curves where this is required. A design can be transferred to lay-out paper by tracing over a template directly in ink – this saves time and assures accuracy in the placement of border sections.

A 2B pencil is best for plotting the designs as the lines produced are clear and the soft lead can be rubbed out easily once the design has been inked in. An 0.5mm automatic pencil is invaluable for

Fig 2.1 Transferring a grid from graph paper to plain paper

interlaced knotwork designs, but for spiral patterns I prefer an ordinary 2B pencil. The thicker lead helps to give a more accurate shape: an 0.5mm pencil shows up the slightest deviation in the outline of the circle but the thicker pencil gives a solid outline for inking in.

Colouring

Water-soluble pencils have a waxy texture and give a good depth of colour which is easily controlled. After the design has been coloured in, water can be painted over the pencil marks to give the effect of a water-colour design. Subtle shading can be introduced in this way, which is particularly effective for spirals, where it is difficult to maintain an even texture and colour because there are no natural 'stopping' points. Felt-tip pens can be used to give an interesting shaded effect to ribbonwork, especially in large designs where the colour 'overlaps'.

The *British Printer*, a periodical published during the later part of the nineteenth century, contains an article which may be useful to the Celtic artist:

'If it is desired to obtain the colour… in all its purity, it is advisable not to use other than good white tones of paper. On blue, black loses all its brightness; on red, it takes up a dark green tinge; on orange, it acquires a bluish cast, and on yellow a violet tinge; on green, it becomes of a reddish-grey, and on violet, greenish-yellow.'

Outlining

To outline the designs, use a fibre-tip pen. These come in a variety of widths and are available from stationers and art shops. As a general guide, choose a fine tip for small designs and a thicker tip for larger ones, although the choice will depend upon the effect you require: if only a small space is required for filling in with colour, outlining a small design with a thick tip would be an appropriate choice. Fibre-tip pens are also useful for filling in backgrounds and to produce various effects such as stoning and graining.

Fig 2.2 A background of feather patterns

PART TWO

---◆---

The Designs

Spirals

Chapter 3

PLOTTING THE DESIGNS

❖

The spiral is a form that occurs frequently in nature, with the shells of nautilus snails and animals' horns included among the well-known examples.

Throughout history it has been of interest to mathematicians. The 'growth' of a spiral follows the numbers in the Fibonacci sequence (a series of numbers in which each unit is the sum of the previous two). While not the method I use, it is interesting to note that the Fibonacci sequence can be applied in order to construct spirals. First draw a set of increasingly large squares, using the series to determine the size of each subsequent square's sides. These squares can then be used to draw the spiral, following a set pattern of placement. Start with a square, the sides of which equal one unit. The second square will also have sides of one unit: $(0) + 1 = 1$. The third square will have sides measuring two units $(1 + 1)$, the fourth will have sides of three units $(1 + 2)$, the fifth, five units $(2 + 3)$, the sixth, eight $(3 + 5)$, and so on.

square 1: $0 + 1 = 1$
square 2: $1 + 1 = 2$
square 3: $1 + 2 = 3$
square 4: $2 + 3 = 5$
square 5: $3 + 5 = 8$

The next step is to position your squares as shown in Fig 3.1. The first two squares are placed one on top of the other. Each

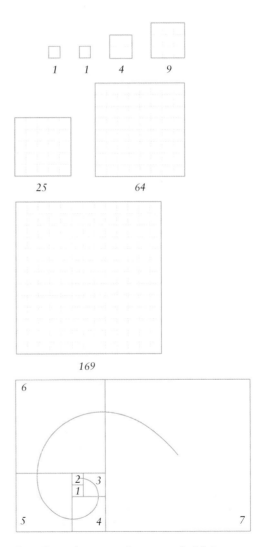

draw diagonals across each square to find their centre, then connect the centres with a continuous curve

Fig 3.1 Applying the Fibonacci sequence to construct a spiral

subsequent square should be placed so that one of its sides is touching, and 'extends' one side of the previous square. Move in a clockwise or anticlockwise direction, according to the direction in which you wish the spiral to rotate.

The first of the two single-unit squares has now served its purpose and should be viewed as a gap from this point. Draw diagonals across each square (leaving the first) to find their centres, then connect the centre of each with a continuous curve. You now have your spiral. The size of the spiral you want will determine the number of squares you must plot.

BASIC PLOTTING TECHNIQUES

I find it easiest to draw curves away from myself and towards the right (I am right-handed). I draw a series of small curves, stopping frequently and beginning each one just before the termination of the last: this slight overlap helps to maintain the continuity of the line.

Drawing away from yourself allows you to always keep the line within your sight; pulling the pencil towards yourself obscures the line and leads to distortions. Lay the little finger edge of your palm

firmly on the table and use it as a pivot point. Holding the pencil between your thumb and first finger as usual, at an angle of approximately 45°, draw a curve away from yourself, towards the right. By retracting or extending your fingers, you can draw small, tight curves or long, sweeping curves. Stop as soon as you feel your wrist check.

Single-exit spirals

A convenient method for constructing spirals with a single exit is to begin by drawing a series of increasingly large circles on graph paper, as shown below in Fig 3.2, with each circle starting and finishing at a point on the outline of the previous one. The radius of each circle is half a unit longer than the previous one, so, where the diameter of the first circle is one unit, the diameter of the second will be two units, the third will be three units, and so on.

Having drawn the circles, in pencil, ink in half of the first circle, then ink in half of the second circle, beginning where it 'extends' from the first, and so on (again, see Fig 3.2). Once half of each circle has been inked in, erase your initial pencil lines, and you will be left with a spiral.

draw a series of increasingly large circles

ink in half of each circle

erase the remaining pencil lines

Fig 3.2 Constructing a single-exit spiral

Ribbonwork

All spirals are lines which curve from and around a centre point. It is the enclosed space between lines that is coloured to produce ribbonwork so, as a single-line spiral does not include a solid, enclosed space, it cannot be treated in this way.

a single line does not provide the enclosed space needed for ribbonwork

by connecting two lines in the centre and closing the end, you create an enclosed space that can be coloured

compare this solid space with the initial single line

two separate enclosed areas can be developed from a three-line spiral

bordering the outside shape creates a background that can be decorated independently of the spiral

Fig 3.3 Creating enclosed areas for decoration

To convert a single-line spiral for ribbonwork, pencil in a dotted line following the curve of the original line. Keep this dotted line at a constant distance from the original. When you are happy

with the dotted line, ink it in, and join it to the original line at the centre (see Fig 3.4). This will give you a double-line spiral which provides two free ends that can either run parallel to each other or travel in different directions, to be used for connecting to other spirals. It also provides the enclosed space necessary for the addition of colour or other decoration.

For a three-line spiral, pencil in two dotted lines, following the procedure given above. The distance between each line must be the same. The addition of this extra line opens up further possibilities for connecting to other spirals and provides two separate enclosed spaces for colouring.

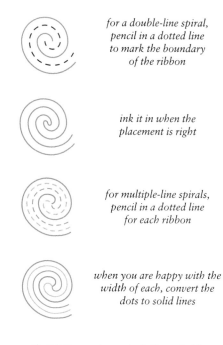

for a double-line spiral, pencil in a dotted line to mark the boundary of the ribbon

ink it in when the placement is right

for multiple-line spirals, pencil in a dotted line for each ribbon

when you are happy with the width of each, convert the dots to solid lines

Fig 3.4 Converting a single-line spiral for ribbonwork

Below is an example of three spirals connected with an s-curve to form a triskele. (See page 21 for an explanation of s- and c-curves.)

Borders may be added to the inside and outside shapes of a design, as shown in Fig 3.5, to create further enclosed areas for additional decoration.

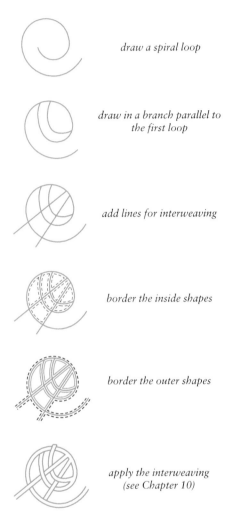

draw a spiral loop

draw in a branch parallel to the first loop

add lines for interweaving

border the inside shapes

border the outer shapes

apply the interweaving (see Chapter 10)

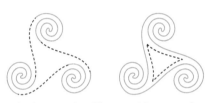

the division of a ribbon provides two ends which can either run parallel with each other, or travel in different directions, to connect with other spirals

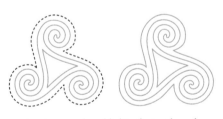

borders may be added to the inside and outside shapes to create further ribbons, and additional space for decoration

Fig 3.5 Bordering inside and outside shapes

Fig 3.6 Adding interwoven ribbons to a spiral

Interweaving can be added to a spiral by branching a ribbon and extending lines across the branches (see Fig 3.6). Any number of free ends can then be provided for the addition of further embellishment and the development of zoomorphics. The size of the initial loop will determine how many branches can be extended.

Multiple-exit spirals

Spirals with more than one exit point can be constructed from a single circle; multiple exits provide more possibilities for variations. The exit points must be placed so that a sense of balance is achieved: two should be placed 180° apart, three should be placed 120° apart and four, 90° apart. The spirals can be plotted either as an individual motif or as a border design. This can be done in four stages (as shown in Figs 3.7 and 3.8), though you don't actually cut the paper on which you are plotting the designs.

1 Divide the circle into the required number of segments.
2 Realign the segments to give the required width.
3 Add construction circles.
4 Draw the outline of each division by following the arc and circle of the relevant segment. To finish the spiral as a motif, take the free ends inwards to connect with each other and enclose the spiral within a circle – this is known as a boss design. To finish the spiral as part of a border, take the free ends outwards to connect with further spirals and form a continuous design.

The number of segments required is determined by the number of exits desired in the spiral; if you want a spiral with two exits (as in a yin/yang symbol), then the circle must be divided into two, if you want four exits in your spiral, you must divide the circle into four.

In 'realigning' the segments, the further they are moved away from each other, the wider the individual segments in the resulting spiral will be.

One circle is added for each segment to provide additional construction lines for the spirals. Once the circles are in place, draw around them to form the centre of each segment, and continue the line round towards the exit.

Where the circles touch or overlap in the centre, there will be no space between the segments (see Fig 3.7); where the circles are smaller and do not meet, space is created in the centre of the spiral, and this can be filled with additional decoration (see Fig 3.8).

At the next stage, the spiral can either be finished as a free-standing motif, or linked to other motifs as part of a border design as shown in Figs 3.9 and 3.10.

Different effects can be achieved by omitting step 2 of this process, though doing this will preclude finishing the spiral as part of a border as it will remain enclosed by the original circle. Compare the examples in Fig 3.8, where the realignment of step 2 has been followed, with those in Fig 3.11, for which step 2 has been omitted.

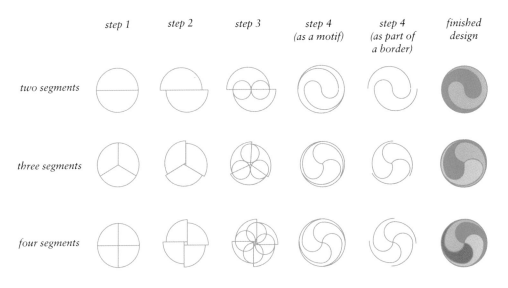

	step 1	step 2	step 3	step 4 (as a motif)	step 4 (as part of a border)	finished design
two segments						
three segments						
four segments						

Fig 3.7 Constructing multiple-exit spirals (construction circles touching/overlapping in the centre)

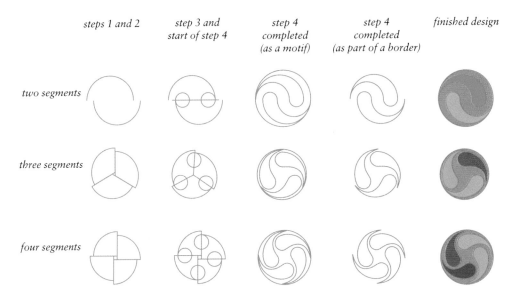

	steps 1 and 2	step 3 and start of step 4	step 4 completed (as a motif)	step 4 completed (as part of a border)	finished design
two segments					
three segments					
four segments					

Fig 3.8 Constructing multiple-exit spirals (construction circles not meeting in the centre)

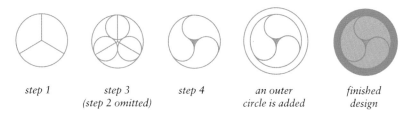

step 1 *step 3*
(step 2 omitted) *step 4* *an outer*
circle is added *finished*
design

Fig 3.9 A free-standing boss design constructed from three circles plotted at 120°

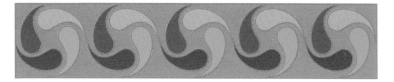

Fig 3.10 Multiple-exit spirals joined to form a border

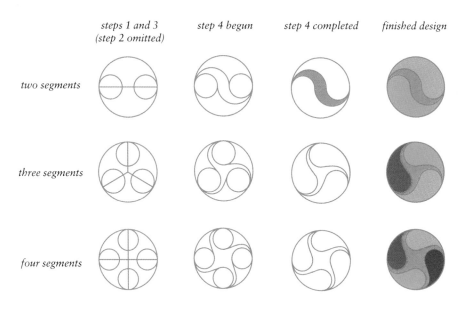

steps 1 and 3
(step 2 omitted) *step 4 begun* *step 4 completed* *finished design*

two segments

three segments

four segments

Fig 3.11 Constructing multiple-exit spirals, without realigning the segments

Ribbonwork

Ribbons can be created by following the same method as for single circles, but starting from a base of concentric circles (see Figs 3.12 and 3.13).

Beginning with a larger circle will allow for more decoration in the centre. To give a sense of movement, the ribbons should be kept equidistant. To achieve this, increase the radius of each successive circle by the same amount.

There can be any number of circles in the base; a large number will produce a long, narrow ribbon – the more circles used, the longer the coil of the spiral will be – and a small number a short, wide ribbon. The circles can be placed close together or further apart, depending on the width required for the ribbon.

When more than four exit points are required for a design it is not practical to make smaller segments inside the circle. However, this problem can be overcome by splitting ribbons, or joining them together at the exit points: eight ribbons can be joined in four pairs and six ribbons in three, and so on. Designs 25 and 26 (see Chapter 5, page 40) both illustrate this technique.

Note that two or more ribbons must leave the spiral in the same direction, after which they may curve gently away from one another – they must not cross each other as they do in interlaced work.

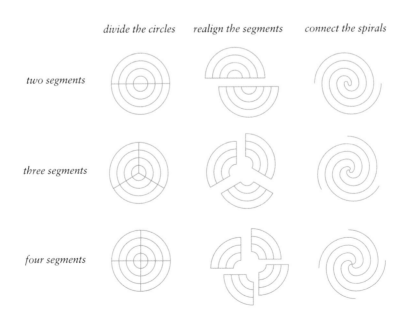

divide the circles *realign the segments* *connect the spirals*

two segments

three segments

four segments

Fig 3.12 Constructing multiple-exit spirals for ribbonwork (with realignment of segments)

divide the circles *connect the spirals*

two-exit spiral

three-exit spiral

four-exit spiral

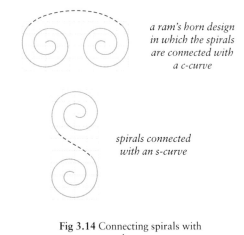

a ram's horn design in which the spirals are connected with a c-curve

spirals connected with an s-curve

Fig 3.14 Connecting spirals with s- and c-curves

Fig 3.13 Constructing multiple-exit spirals for ribbonwork (without realignment of segments)

Connecting spirals

Spirals can be connected with s-curves, c-curves or a combination of both. The direction and position of the exit points of the spirals to be joined will determine which curve is required. Examples are given below.

Further variety can be introduced by using different sizes of circle as the basis for a design, but to retain a sense of balance, the ribbons should be kept in proportion (see Designs 34 and 35 in Chapter 5, page 48).

the connecting curves *finished designs*

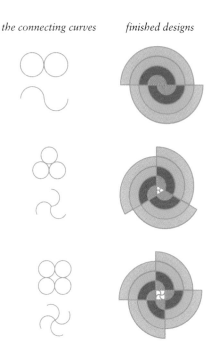

Fig 3.15 Connecting the centres of spiral ribbons

Plotting spiral designs

Spirals can be plotted so that their free ends exit in any direction, as shown in Figs 3.16 and 3.17. A grid can be used to set out the designs accurately: it is essential to maintain the balance of spiral designs by placing the exit points equidistant from each other. The spiral designs in this book are plotted in three steps:

1 Place all the spirals on the gird.
2 Connect the spirals with s- or c-curves.
3 Outline or embellish the shapes between the spirals if desired.

Closing off a border

To close off or complete a border, place a sheet of tracing paper over the design to determine the best path for curving in the free ends. When finishing the ends of a spiral border, if ribbons of the same colour can be joined, join them, provided the design is not significantly changed. Where this is not possible, 'lose' the ends of the ribbons by gradually fading them into the adjacent ribbon.

There are no hard and fast rules for closing off a border, it is simply a matter of not finishing ends abruptly.

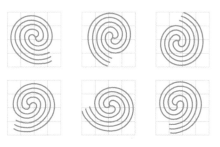

Fig 3.17 Multiple-line spirals plotted with exit points at any different angles

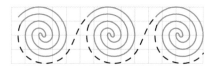

place the spirals on the grid

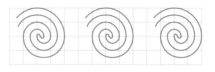

connect the spirals with appropriate curves

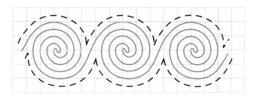

border the outer shapes to produce a double ribbon

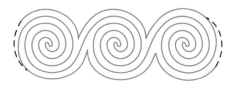

join ribbons and curve in free ends to close off the design

Fig 3.18 Plotting spiral designs

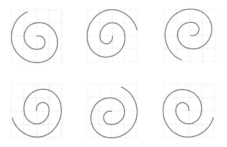

Fig 3.16 Spirals can be plotted with their exit points at any angle, and mirror-imaged

General plotting tips

1 Use graph paper to plot your first efforts and to experiment with layouts.

2 It is helpful, at first, to use a circle template to ensure that your foundation loops are accurate; this will help you create ribbons of an even width.

3 The more circles that you use in plotting a spiral, the longer the coil of the spiral will be.

4 Plotting the base circles closely together will create a tight spiral, plotting them further apart a looser one.

5 Motifs can be adapted to give a border design by extending the free ends outwards to join adjacent spirals.

6 Starting with a larger base circle will leave more space in the centre of the spiral for decoration.

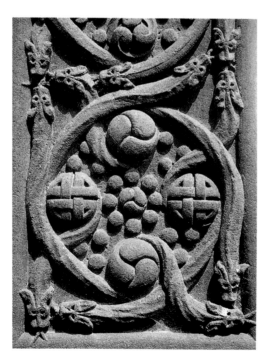

Fig 3.19 Zoomorphics, spirals and knotwork are combined in this carving

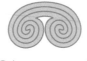

Chapter 4

Two- & Three-Ribbon Designs

◆

1

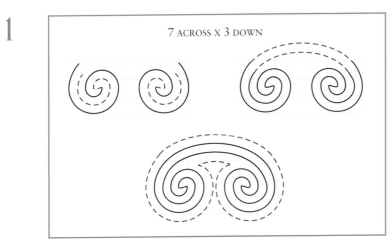

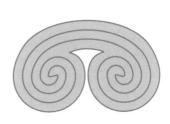

A ram's horn design in which the spirals are
connected with a c-curve and outlined

2

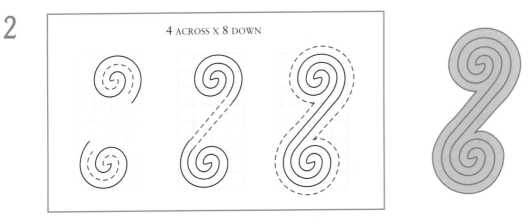

The spirals are connected with an s-curve and outlined

3

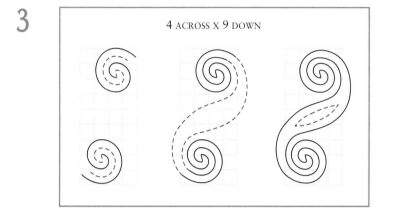

4 ACROSS X 9 DOWN

A variation of Design 2 in which the spirals are plotted further
apart and connected with wider s-curves – trumpet spirals.
Additional decoration is added to the centre and there is no
outline. The motif is a single ribbon which divides in the centre

4

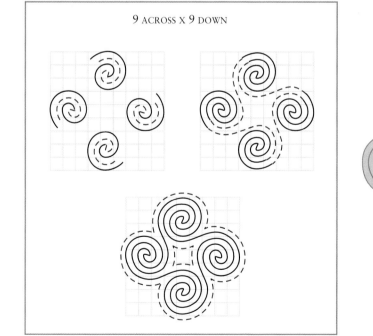

9 ACROSS X 9 DOWN

The spirals are plotted in a swastika pattern and connected with s-curves

5

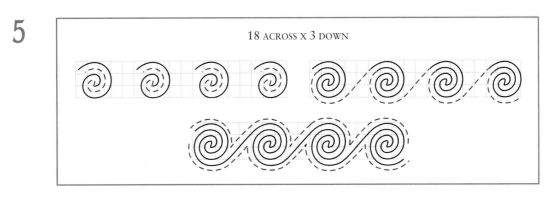

18 ACROSS X 3 DOWN

A simple border of spirals. Keep the dividing line parallel to the construction line as it passes underneath the spiral

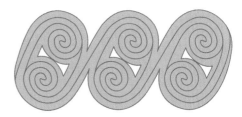

6

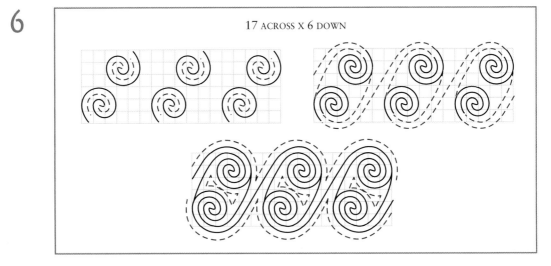

17 ACROSS X 6 DOWN

Pairs of spirals are plotted close together and the dividing line of each runs into the outline of the other. The construction lines are joined with long s-curves

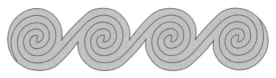

7

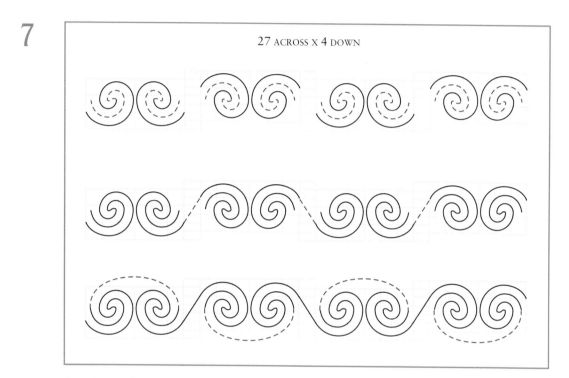

27 ACROSS X 4 DOWN

A variation of Design 1 showing an alternative method of plotting the spirals in a continuous border pattern, using s- and c-curves

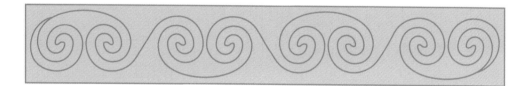

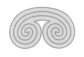

8

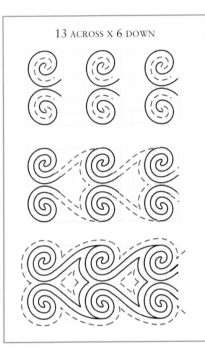

13 ACROSS X 6 DOWN

In this border design, the top and bottom rows are a mirror image of each other. The exit points of the spirals are extended to border the inside shapes and the outside border adds a further ribbon

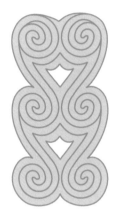

9

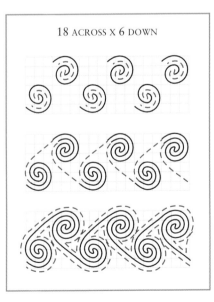

18 ACROSS X 6 DOWN

Spirals are connected with c-curves in this wider border design

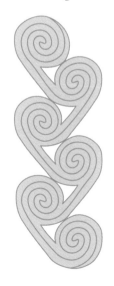

10

15 ACROSS X 8 DOWN

Pairs of spirals are connected to form a border pattern using s-curves

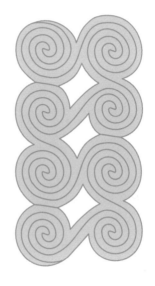

11

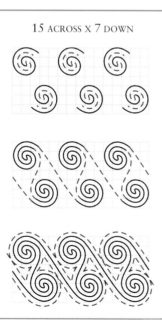

15 ACROSS X 7 DOWN

A border pattern which is a variation of Design 2

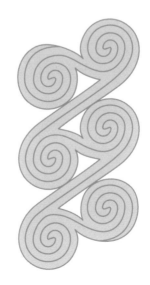

12

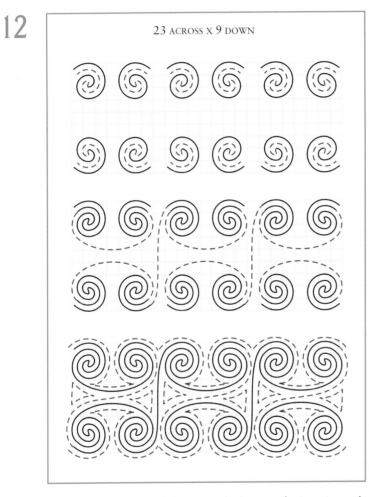

23 ACROSS X 9 DOWN

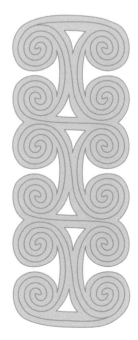

An arrangement of ram's horns in which pairs of mirror-imaged spirals are connected into a border pattern using s-curves

13

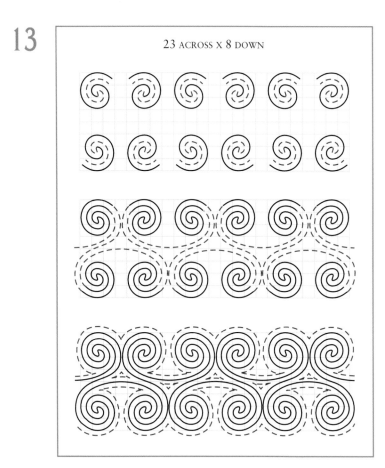

23 ACROSS X 8 DOWN

A variation of Design 12, using two s-curves
to connect the ram's horns

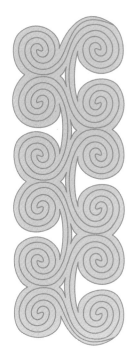

14

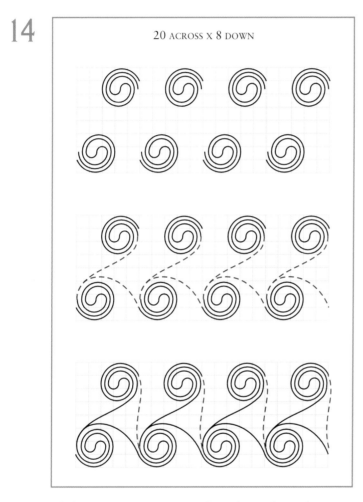

20 ACROSS X 8 DOWN

The lower row connects pairs of spirals together with s-curves

15

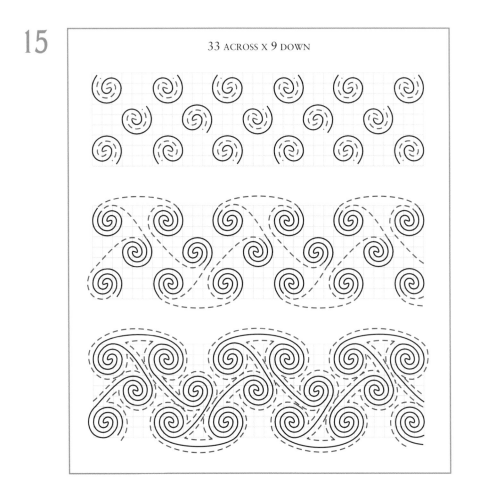

33 across x 9 down

A further variation of Design 7 in which the insertion of a line of spirals between the ram's horns produces a wider border

16

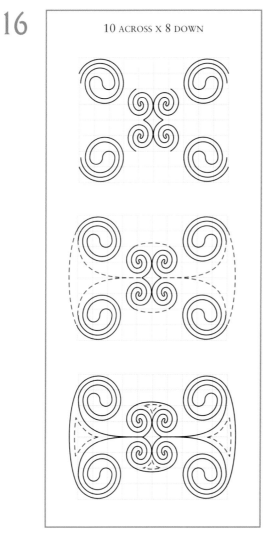

10 ACROSS X 8 DOWN

A motif combining small and large spirals
which are connected by ram's horns

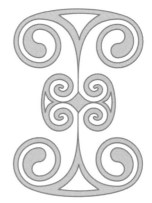

17

12 ACROSS X 7 DOWN

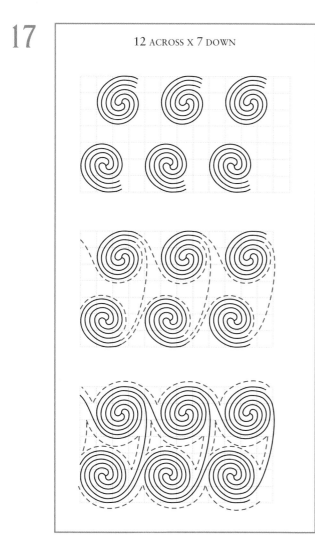

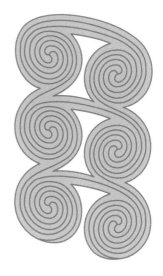

Two rows of spirals connected with s- and c-curves
produces a border design of three ribbons

18

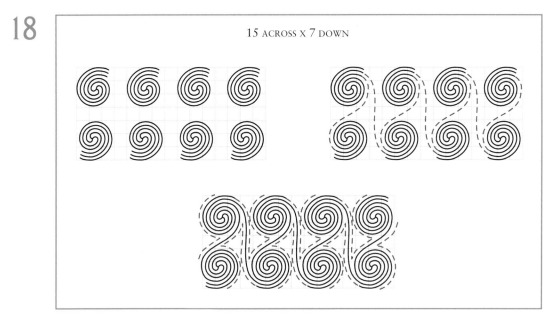

15 ACROSS X 7 DOWN

This three-ribbon border design uses only s-curves to connect the spirals.
The third ribbon is used to border the shape between the spirals

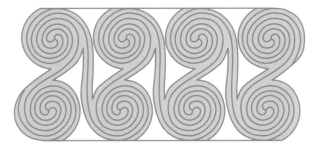

19

11 ACROSS X 8 DOWN

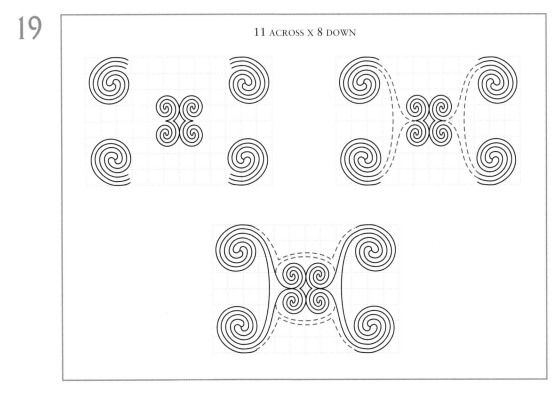

A variation of Design 16, with three ribbons

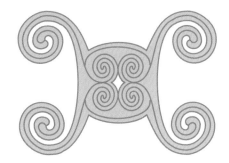

Chapter 5

Two, Three & Four Exit Points

◆

20

13 ACROSS X 3 DOWN

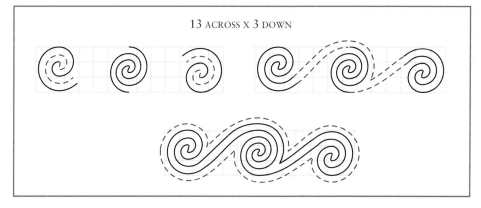

A variation of Design 2 in which a two-exit point spiral is plotted in the centre of the design

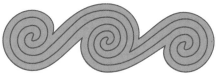

21

9 ACROSS X 9 DOWN

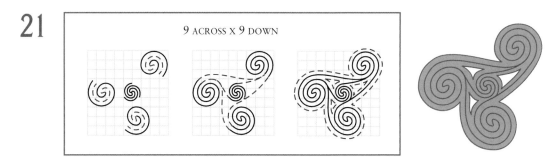

A spiral with three exit points is plotted in the centre of the triskele. The second line (centre division) of each outer spiral branches to connect it to both the centre spiral and the adjacent spiral, moving in an anti-clockwise direction

22

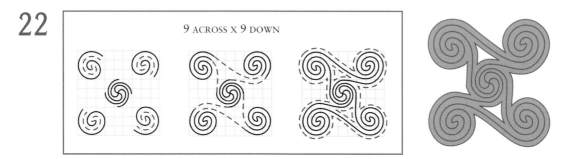

9 ACROSS X 9 DOWN

Two-ribbon spirals are arranged to form a swastika around a central spiral with four exit points. The spirals are connected with s-curves as in the previous designs

23

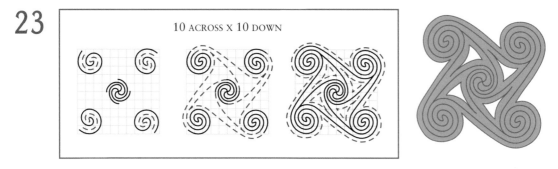

10 ACROSS X 10 DOWN

A variation of Design 4 in which extra ribbons are created by dividing the second line of each spiral at its exit point. One end is then joined to the centre spiral with a c-curve and the other to an adjacent spiral with an s-curve

24

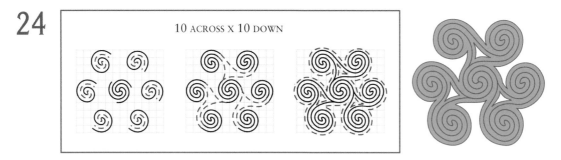

10 ACROSS X 10 DOWN

A design based on triskeles in which pairs of spirals enter a centre spiral that has three exit points

25

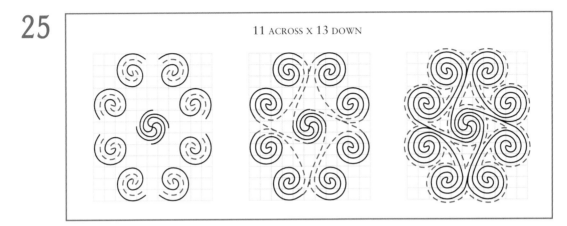

11 ACROSS X 13 DOWN

In this motif, four pairs of spirals enter a centre spiral with four exit points. There are four interlocking ribbons

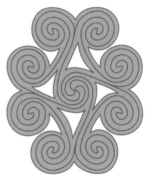

26

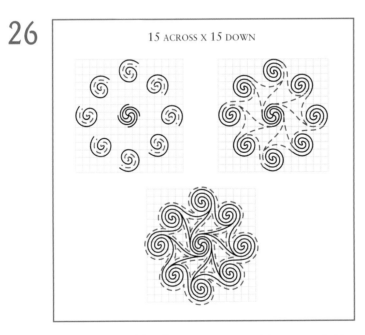

15 ACROSS X 15 DOWN

The centre spiral has four exit points and is surrounded by eight spirals, all connected to each other and joined to the centre spiral in pairs

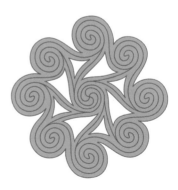

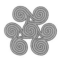

27

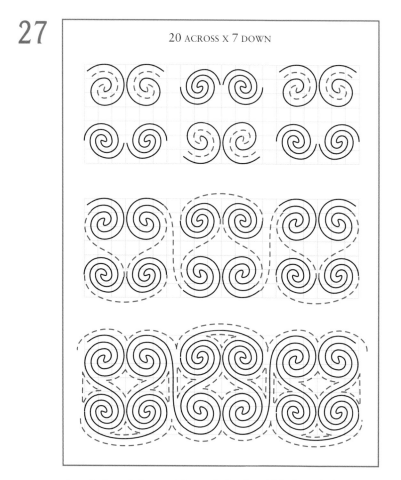

20 ACROSS X 7 DOWN

A variation of the ram's horn design in which the spirals
are plotted alternately and connected with c- and s-curves

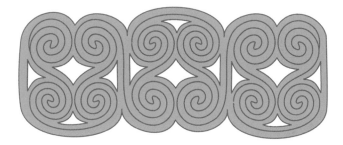

28

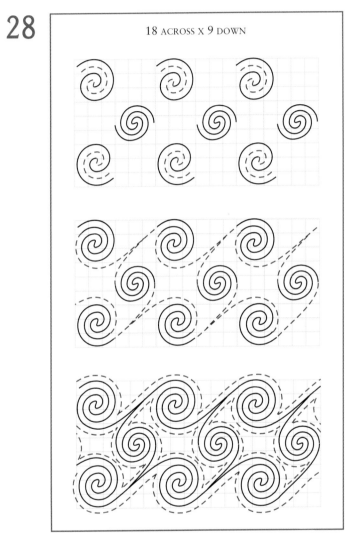

18 ACROSS X 9 DOWN

A variation of Design 5 in which rows of
spirals are connected with c- and s-curves

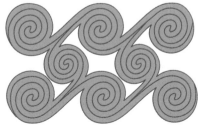

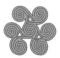

29

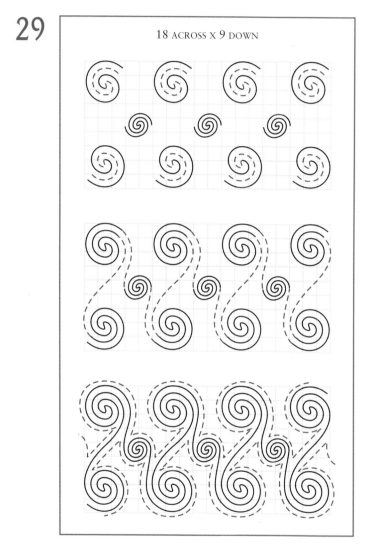

18 ACROSS X 9 DOWN

The smaller spirals in the centre demonstrate the effect which can be achieved by combining different sizes of spirals in a design

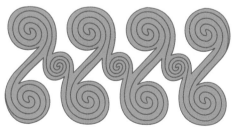

30

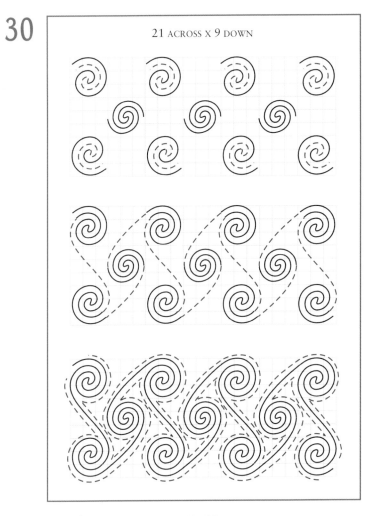

21 ACROSS X 9 DOWN

A similar pattern to Design 29, this
one using both s- and c-curves to
connect the spirals

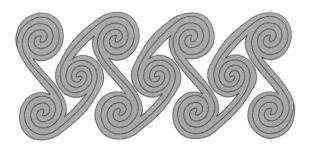

31

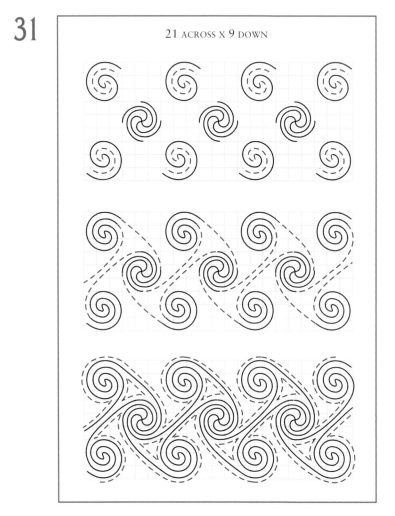

21 ACROSS X 9 DOWN

The centre spirals of this border have four
exit points and use c-curves to connect to
the other spirals

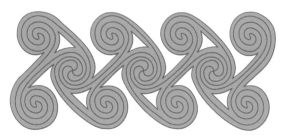

32

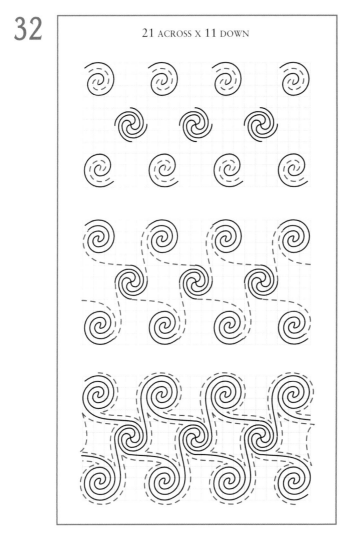

21 ACROSS x 11 DOWN

A variation of Design 11 in which the
spirals are connected with s-curves

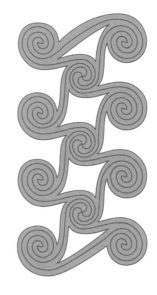

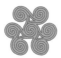

33

15 ACROSS X 8 DOWN

A border of three-ribbon spirals which connect alternately

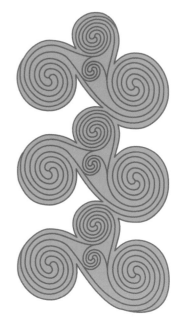

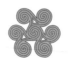
34

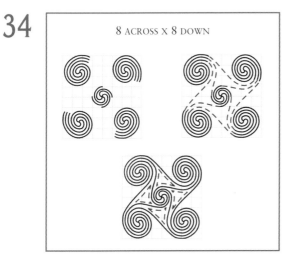

8 across x 8 down

A variation of Design 22 in which four spirals are connected to a four-exit centre spiral

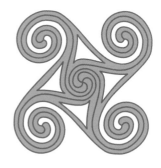

35

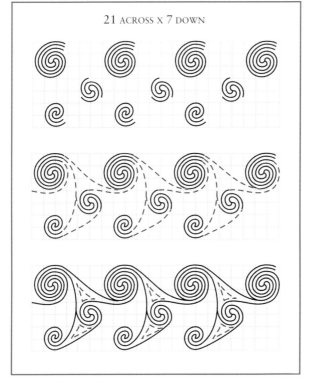

21 across x 7 down

A combination of two- and three-ribbon spirals connected to three-exit spirals in the centre

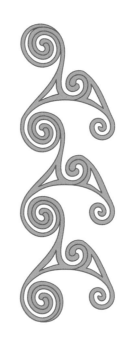

36

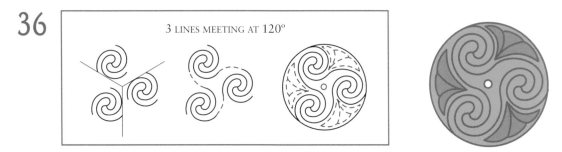

3 LINES MEETING AT 120°

Lines rather than squares are used for plotting these three-exit spirals, arranged within a circle as a boss design. The spirals are connected with s-curves, using two of the exit points, and the third is extended to run into the surrounding circle. The spaces are filled with additional decoration

37

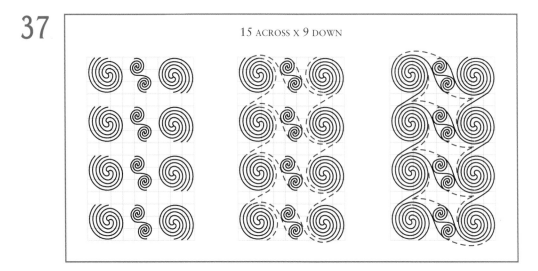

15 ACROSS X 9 DOWN

A combination of two- and three-ribbon spirals in a border design

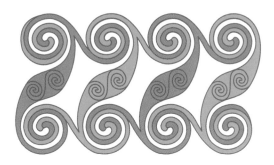

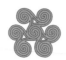
38

15 ACROSS X 11 DOWN

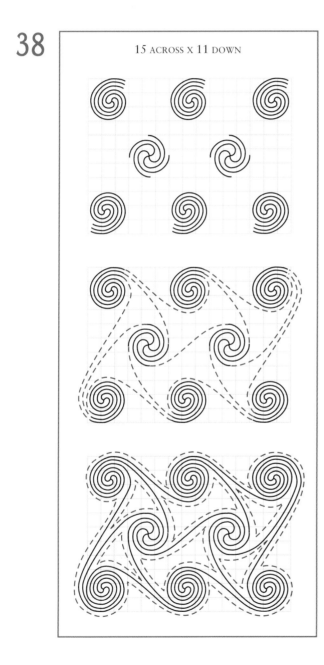

The final design in this section is from the Moylough belt shrine in Tubbercurry, Co. Sligo, Ireland. It is a motif which connects three-exit spirals to four-exit spirals in the centre

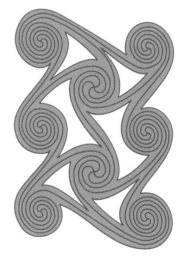

ALL-OVER DESIGNS

Chapter 6

Plotting the Designs

As mentioned earlier, the Egyptians used spiral designs set out as all-over patterns to decorate the ceilings of tombs, often incorporating plant motifs, interlocking spirals and flattened scrolls.

I have not given a recommended size of grid for these designs as, by their nature, they can be plotted to fill whatever the available space, varying in units across and down accordingly. The designs given in Chapter 7 are all diapers – patterns consisting of a small, repeating design.

BASIC PLOTTING TECHNIQUES

While these all-over designs are spirals, I have followed a slightly different procedure for plotting them than for the borders and motifs in the previous chapters. I begin one step back, with the

base circles rather than completed spirals, and add the connecting s- and c-curves before plotting the spirals and exit points: for all-over designs, it is these connecting lines that determine the number of exit points required for each spiral. All-over designs can be plotted in four stages:

1 Set out the circles.
2 Add the connecting s- and c-curves.
3 Convert the circles to spirals, plotting the ribbons and exit points of the spirals.
4 Outline the shapes and add any further decoration and embellishment.

Experiment with placing the circles close together or further apart, and also varying the size of individual circles. Setting the circles further apart will increase the size of the spaces available for filling with background patterns or stylized leaves.

Chapter 7

Diapers

◆

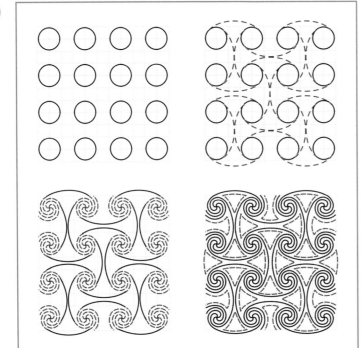

In this design, all the spirals are connected with c-curves and have four exit points

40

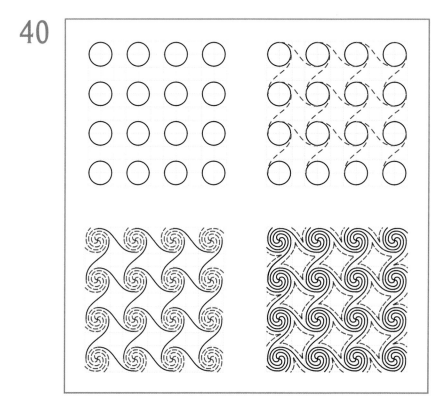

Spirals with four exit points, connected with s-curves

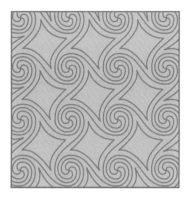

41

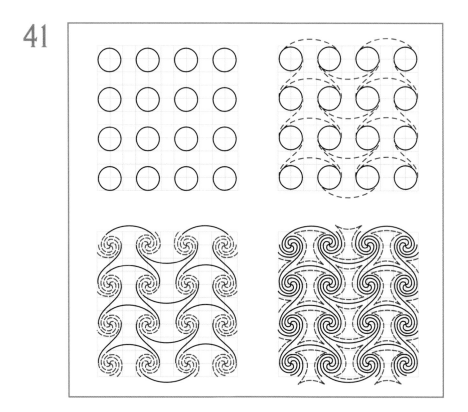

A combination of both s- and c-curves connect these
spirals with four exit points

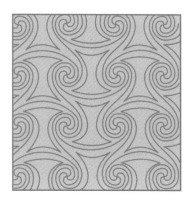

42

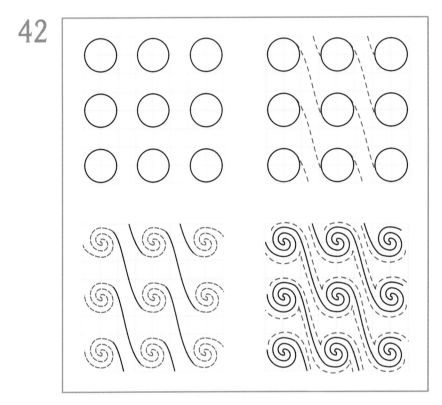

This pattern is constructed from diagonal rows of two-exit spirals

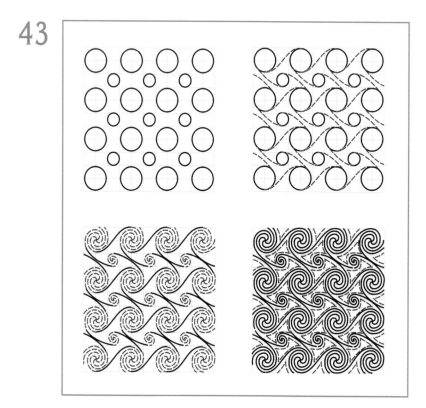

43

An arrangement of large and small circles connected with
s- and c-curves. The small circles have two exit points and
the large circles have four

44

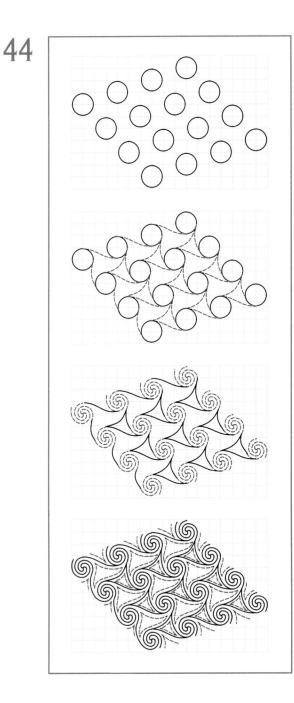

An example of dividing the line at the point of exit to allow spirals to be connected into an all-over pattern

45

The spirals in this design are connected with s-curves and have two exit points

46

Spirals plotted in diagonal lines are connected with s-curves

47

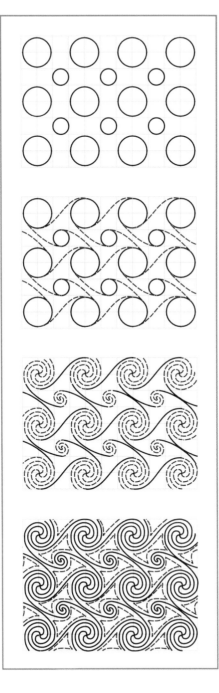

A variation of Design 43 in which the c-curves connecting the small circles meet in the centre

The Pelta

Chapter 8

Plotting the Designs

◆

The original pelta was the leather-covered shield of wicker work that was carried by Thracian warriors. Later, the motif on these shields came to be referred to as a pelta and it became an important design element in early decoration. It was used frequently in Greek and Roman decorative art, particularly in mosaic pavements and friezes.

It is acknowledged that patterns plotted from a base of straight lines were undoubtedly developed from the plaitwork found in Greek and Egyptian decoration, but it is possible that the pelta is the foundation of all Celtic knotwork designs in which hearts, small, large and extended loops are found.

Simple to construct, light and easy to carry, the shield was an ideal mathematical instrument for executing complicated designs with accuracy. It could be used as a template to plot circles, to mark equidistant points, draw connecting curves and accurately divide circles into two, three, four or six equal parts.

Grid sizes have not been given for these designs as peltas are constructed from a circle of indeterminate size and two smaller circles contained within this; the size of the first circle is unimportant, as long as the inner two are in proportion.

BASIC PLOTTING TECHNIQUES

A pelta is constructed from three circles; two smaller circles of the same size enclosed by one larger circle with a radius twice the size of the inner two (as shown in Fig 8.1).

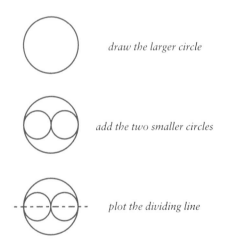

draw the larger circle

add the two smaller circles

plot the dividing line

Fig 8.1 Constructing a pelta

Common motifs that can be developed straight from a basic pelta include the yin/yang symbol and a swastika design, as illustrated above right.

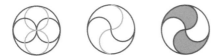

the yin/yang symbol developed from a pelta

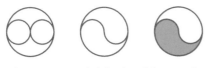

four half peltas form a swastika design

Fig 8.2 Common motifs developed straight
from a pelta

The motif can also be divided into two sections, equal or unequal, which can be used as templates. I will refer to these sections as 'pelta arcs'. Dividing the motif further from the centre line will give one section with higher arcs and the other with correspondingly shallower arcs.

By modifying the basic pelta and reducing the relative size of the smaller circles (so that the larger circle has a radius more than twice that of the smaller circles), you can create space in the centre of the motif for additional decoration.

Fig 8.4 Reducing the size of the inner circle provides space in the centre for additional decoration

Spiral designs

Spiral designs can be plotted from a pelta base in three steps:

1 Plot all the pelta arcs.
2 Add spirals to fill the spaces created between the arcs.
3 Border and embellish the inside shapes if desired.

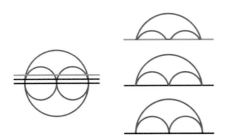

the height of the arcs can be reduced by dividing the motif further from the centre line

designs can be plotted with accuracy using the pelta as a template

Fig 8.3 Dividing the pelta to form pelta arcs

Chapter 9

Pelta Spirals

◆

48

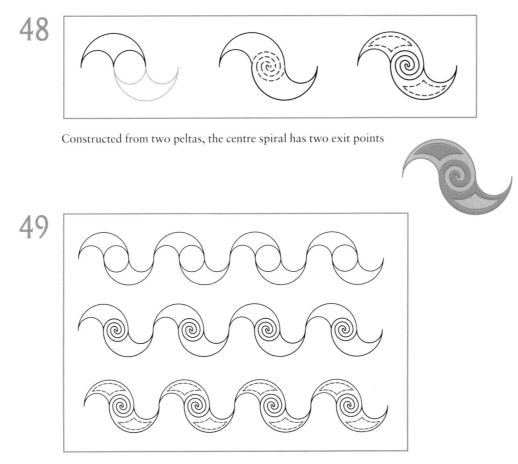

Constructed from two peltas, the centre spiral has two exit points

49

A border pattern of spirals constructed from Design 48

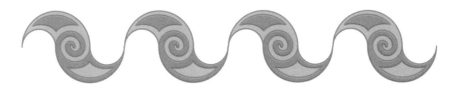

50

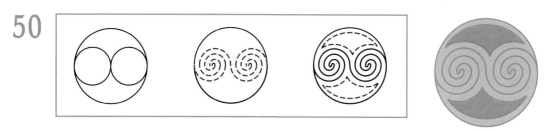

This boss design is constructed from two peltas with a two-exit spiral inserted into each space

51

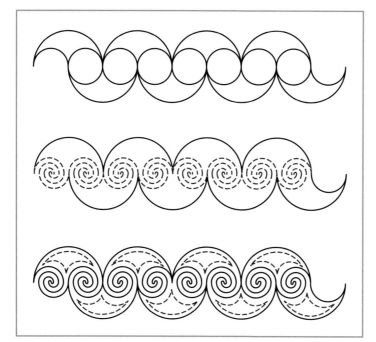

Peltas are placed facing up and down alternately, with their centre points touching. A double-line spiral fills each space

52

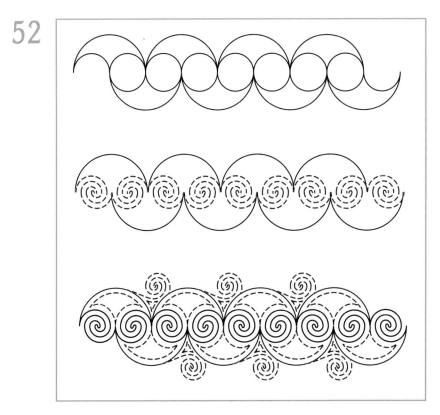

A variation of Design 51 in which the peltas are
embellished with additional double-line spirals

53

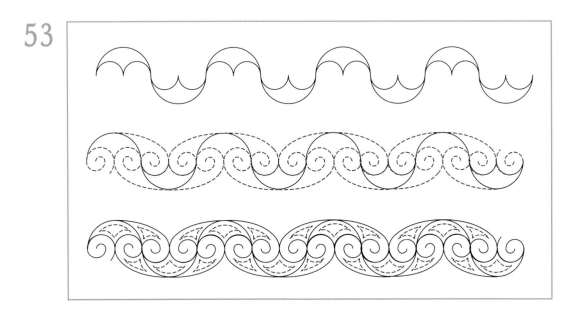

Single-line spirals are placed back-to-back and
attached to the top of adjacent peltas with an arc

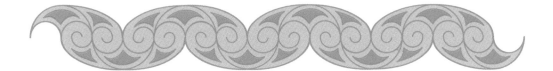

54

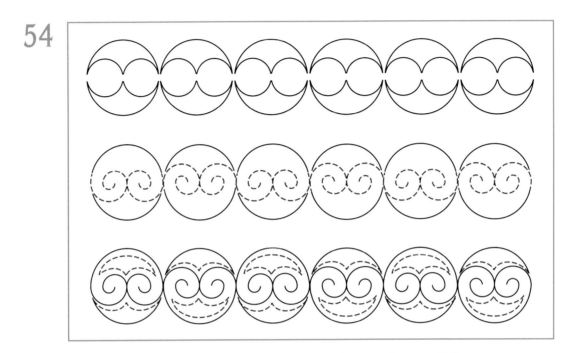

A single-line spiral is extended from alternate upper and lower pelta arcs which
then have their inside shapes bordered. The remaining pelta arcs are embellished
to resemble a border of smiling faces

55

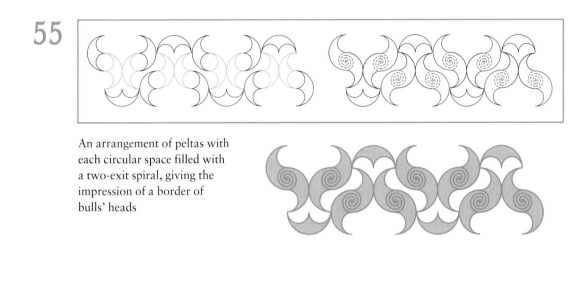

An arrangement of peltas with
each circular space filled with
a two-exit spiral, giving the
impression of a border of
bulls' heads

56

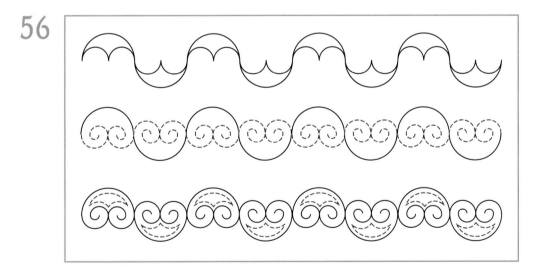

Single-line spirals are set into the arcs of each pelta to form a border design

57

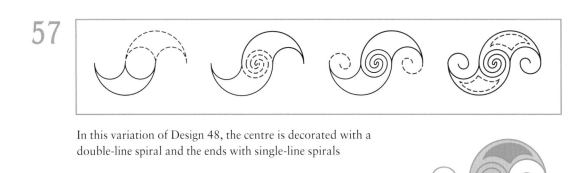

In this variation of Design 48, the centre is decorated with a double-line spiral and the ends with single-line spirals

58

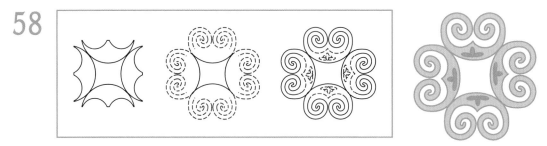

A motif formed by placing four pelta arcs back-to-back and filling them with double-line spirals

59

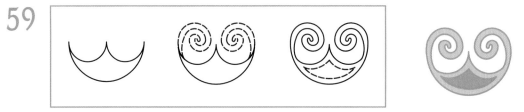

Double-line spirals decorate each end of an inverted pelta

60

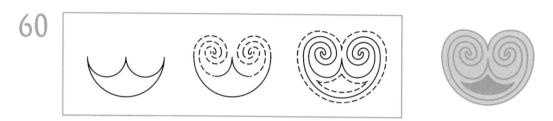

A simple variation of Design 59 in which the spirals are extended
to meet in the centre

61

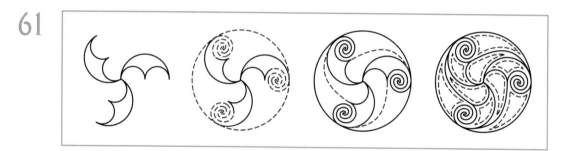

In this design, the peltas are arranged around a central point at 120°
from one another, and decorated with double-line spirals. This
pattern is then set within a circle and the inside shapes are bordered

62

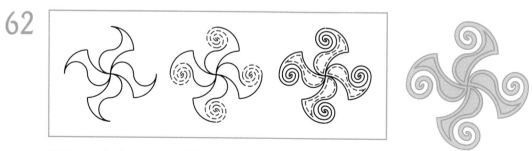

This swastika is constructed from half peltas decorated with spirals

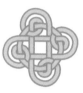

Interwoven Designs

Chapter 10

Plotting the Designs

◆

Interwoven knotwork is developed from plaitwork. Plaitwork patterns consist of straight, diagonal lines joined together with curves, as in the example shown in Fig 10.1. They are characteristic elements of Roman, Greek and Egyptian art.

pointed loops to fill in corners, and used a variety of motifs to close off knotwork ribbons. In this way, even the simplest ribbon could be woven into intricate patterns, producing secondary ribbons which were sometimes highlighted by using a different colour for each lacing.

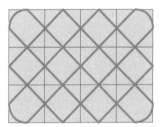

Fig 10.1 Roman plaitwork

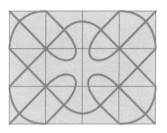

Fig 10.2 Celtic knotwork showing the break in lines in the centre

In the sixth century AD, plaitwork was used extensively in Italian churches to decorate altar screens and covers for various church vessels.

The plaitwork decorations of this time show a development from the early designs that opened up greater possibilities for the creation of more intricate patterns. Instead of using continuous diagonal lines they used broken lines, which enabled interweaving.

The Celts also used broken lines in their own distinctive, interwoven knotwork (see Fig 10.2). Because they used their knotwork to decorate irregular spaces on stone crosses, manuscripts, jewellery and wood, they also added angular lines and

As the designs in Chapter 11 have all been constructed from circles, grid sizes have not been given.

BASIC PLOTTING TECHNIQUES

The designs in this section have all been developed from the base elements – spirals, circles and peltas – covered in the previous chapters. The lines which weave through their centres do so at angles of 90°, 45° or a combination of both. The circles can be any size; if plotted initially on squared paper, the centre, where the lines will cross, is easy to locate.

It is difficult to give a general process that applies to all the interwoven designs in Chapter 11 as they have been developed from differing base elements. For this reason, each step has been explained for all the individual designs.

The list of steps given below can be followed, though not every step is needed for each design.

1 Plot all the base elements.
2 Add any further construction lines.
3 Erase any unnecessary construction lines.
4 Add connecting lines.
5 Identify crossing points for interweaving.
6 Ink in outlines.

Ribbonwork

Ribbons are bands of a consistent width. In all ribbonwork, the complete width of each ribbon must be shown, so where two or more ribbons pass through a space, their combined width must not be greater than the width of that space. For this reason, the width of the ribbons is determined by the smallest available space in the design (see Fig 10.3).

There are two methods for creating ribbons – both start with the basic line work drawing.

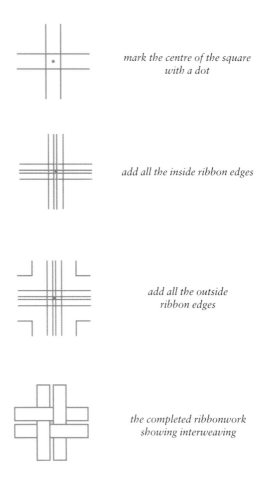

mark the centre of the square with a dot

add all the inside ribbon edges

add all the outside ribbon edges

the completed ribbonwork showing interweaving

Fig 10.3 Ribbon width is determined by the smallest available space in a design

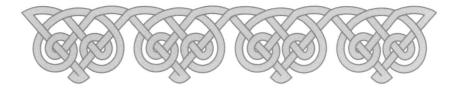

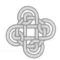
METHOD 1

The first method is to draw lines on either side of the original lines, parallel to the originals and equidistant from them. In simple patterns the crossing points can be easily identified (see Figs 10.4 and 10.5) and the ribbon can then be inked in following them. After inking, the construction lines can be erased (see Figs 10.6 and 10.7) and further lines added to form continuous ribbons (see Fig 10.8).

Fig 10.4 Lines are drawn either side of the original vertical lines, parallel to them

Fig 10.5 Parallel lines are drawn either side of the horizontal lines. Where these cross the vertical lines, interweaving will take place

Fig 10.6 The horizontal ribbons are inked in following the interweaving shown in Fig 10.5

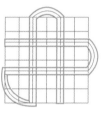

Fig 10.7 With the vertical lines inked in, the ribbonwork is complete

Fig 10.8 Converting Fig 10.7 to a continuous ribbon by adding curved connecting lines

METHOD 2

In more complex designs, the additional construction lines and points of intersection can be very confusing and difficult to follow. The second method for plotting ribbonwork helps to alleviate this by removing the lines at the crossing points. Rather than drawing in the new lines along the entire length of the original lines, lines on the inner side are drawn only up to the point where they meet the other new construction lines, as shown in Fig 10.9 (bordering the inside shapes), and a continuous line is drawn around the outer sides (bordering the edge). It is often simpler to complete the bordering in two or more stages, for example, bordering the lower edge before starting on the upper edge of the design. As with Method 1, all the new lines must be parallel to and equidistant from the original lines.

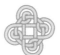

Figures 10.9–10.12 show the plotting of ribbonwork following Method 2. Where the construction of ribbonwork is shown in this book, it is done following Method 2.

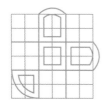

Fig 10.9 Bordering the inside shapes; the border is half the width of the final ribbon

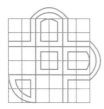

Fig 10.10 Bordering the upper edge. Again, the outside border is half the width of the final ribbon

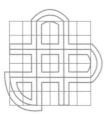

Fig 10.11 Bordering the lower edge

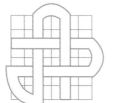

Fig 10.12 The completed ribbonwork motif

Double ribbons

Two ribbons drawn together, each finished in a different colour, create an interesting effect. As the interweaving for double ribbons is quite complicated, initial attempts at double ribbons should be worked on large squares.

Plotting is the same as for single ribbons (plotting the line drawing and bordering the inside shapes and edges), but what would be half a ribbon for single ribbons is treated as a whole ribbon for double ribbons, and this affects the crossing points.

The interweaving of the first ribbon must be the opposite of that of the second; at a point where the first ribbon crosses over, the second ribbon must pass under and vice versa.

Because the additional ribbon makes the interweaving more complicated, it is helpful to add guidelines to your pencil drawing to indicate where each ribbon will pass under at a crossing point. Complete the guidelines for one whole ribbon, passing alternately over and under, before starting to mark the second. Remember that whatever pattern you have chosen for the first ribbon, the pattern for the second ribbon should be the opposite.

With the interweaving indicated, ink in first one ribbon, and then the other as shown in Fig 10.13, on page 80.

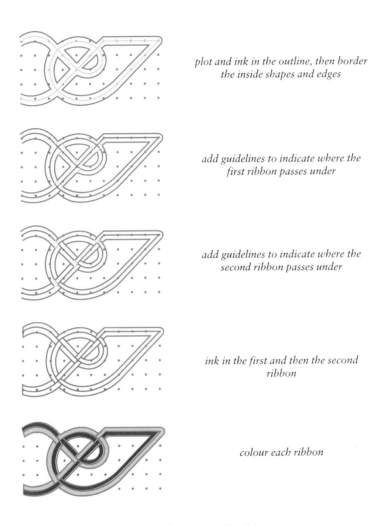

plot and ink in the outline, then border
the inside shapes and edges

add guidelines to indicate where the
first ribbon passes under

add guidelines to indicate where the
second ribbon passes under

ink in the first and then the second
ribbon

colour each ribbon

Fig 10.13 Plotting a double ribbon

Chapter 11

INTERWOVEN MOTIFS
& BORDERS

◆

63

plot the base elements *add connecting lines*

border the pelta arcs *border the inner square*

Peltas arranged to form two interwoven links

64

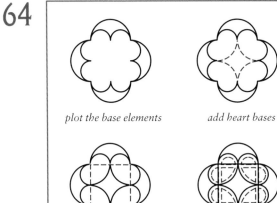

plot the base elements *add heart bases*

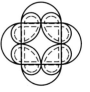

add connecting lines *apply the ribbonwork*

Pelta arcs are used to construct four interwoven hearts, the bases of which are quarter circles

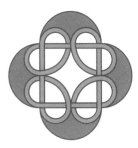

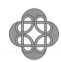

65

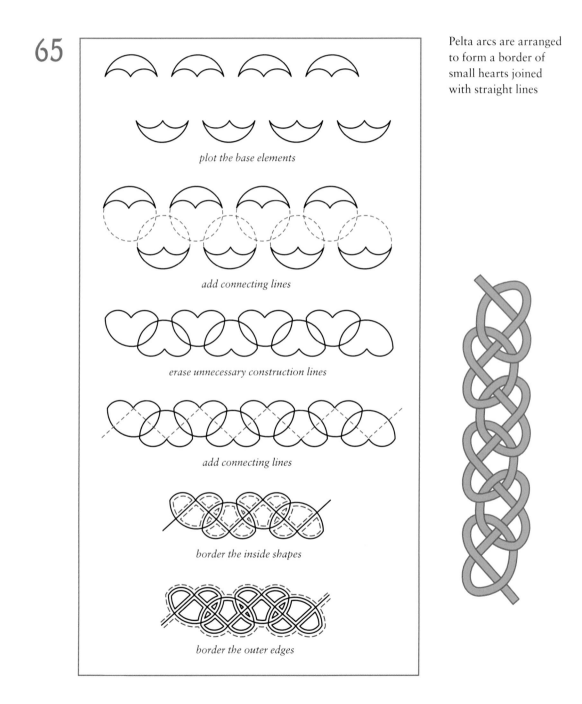

plot the base elements

add connecting lines

erase unnecessary construction lines

add connecting lines

border the inside shapes

border the outer edges

Pelta arcs are arranged to form a border of small hearts joined with straight lines

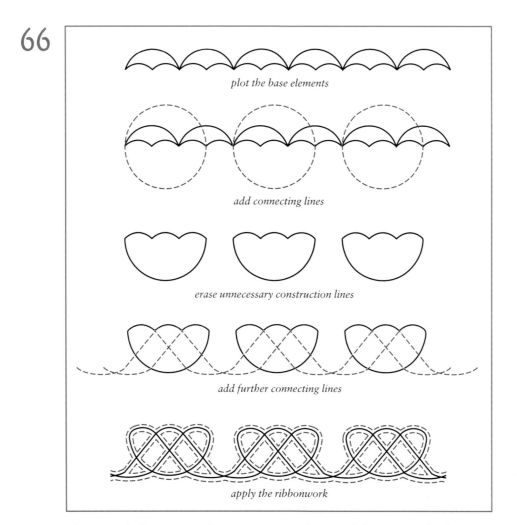

plot the base elements

add connecting lines

erase unnecessary construction lines

add further connecting lines

apply the ribbonwork

66

This example demonstrates the construction of the extended loop using the three points of a pelta arc as a guide for accurate plotting. The diameter of the large circle is 1½ times that of each pelta arc

67

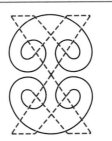

plot the base elements

add connecting lines

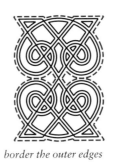

border the inside shapes

border the outer edges

The single-line spirals are joined with a c-curve, and the two motifs are connected with straight lines to form one continuous motif

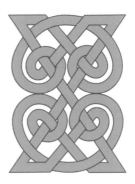

68

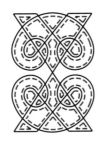

plot the base elements

add connecting lines

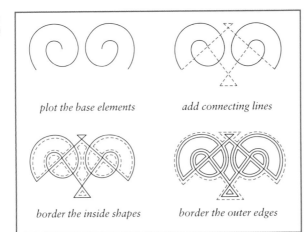

border the inside shapes

border the outer edges

In this design, diagonal lines are taken from the free end of each spiral and woven into a simple knot motif. Twists have been added for further decoration

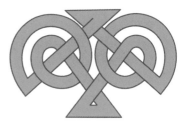

69

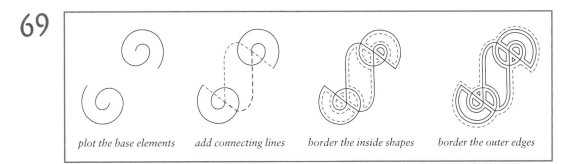

plot the base elements *add connecting lines* *border the inside shapes* *border the outer edges*

This knot has been created by extending lines from the free ends of the spirals as an alternative to joining them with an s-curve

70

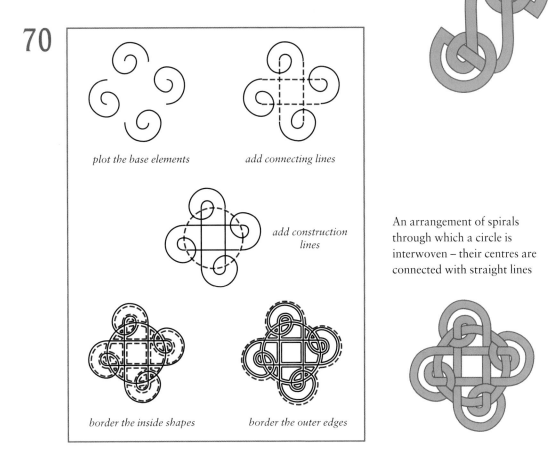

plot the base elements

add connecting lines

add construction lines

border the inside shapes

border the outer edges

An arrangement of spirals through which a circle is interwoven – their centres are connected with straight lines

71

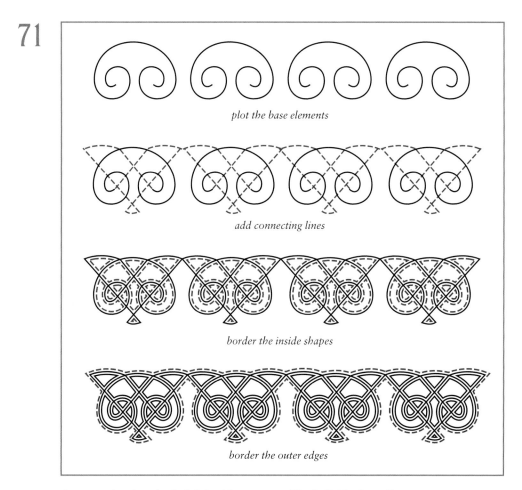

plot the base elements

add connecting lines

border the inside shapes

border the outer edges

A narrow border of spirals joined by c-curves. The individual motifs are connected by straight lines, and two ribbons interweave throughout the design

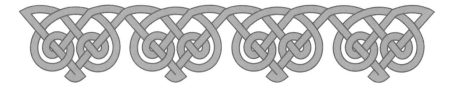

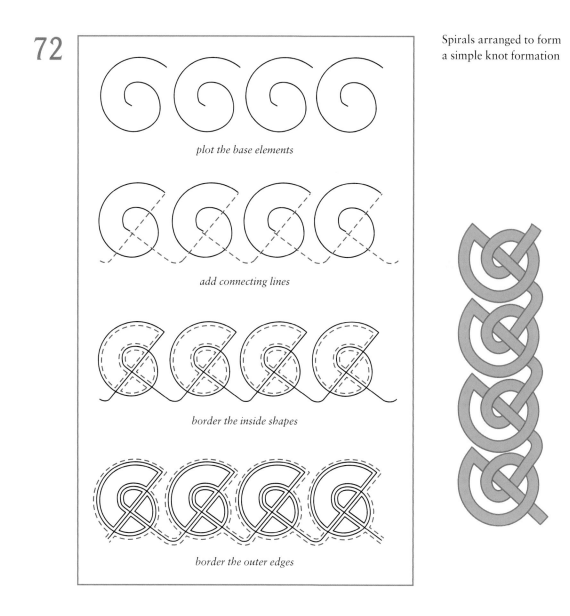

72

plot the base elements

add connecting lines

border the inside shapes

border the outer edges

Spirals arranged to form
a simple knot formation

73

plot the base elements

add connecting lines

border the inside shapes

border the outer edges

A variation of Design 72 in which two rows of spirals are interwoven to construct a wider border. The angle at which the spirals connect is not important, but do make sure that there is enough space between each to allow for a reasonable ribbon width

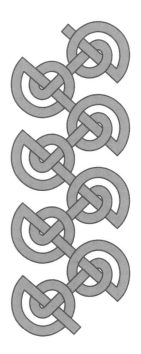

A repeating border
design constructed
from a base of spirals

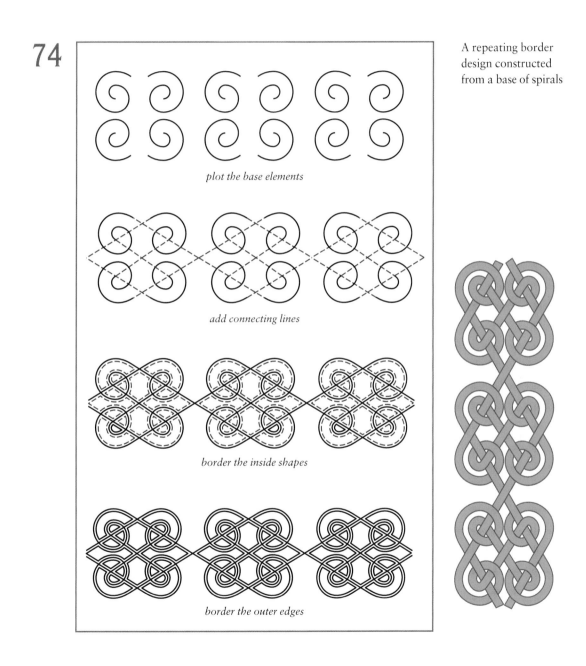

plot the base elements

add connecting lines

border the inside shapes

border the outer edges

75

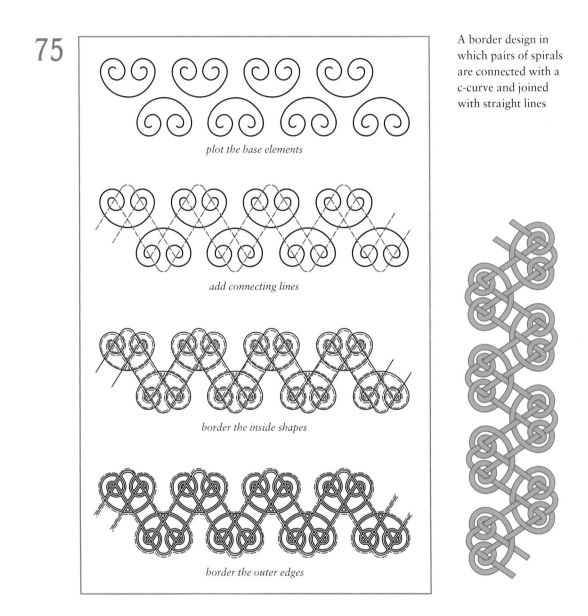

plot the base elements

add connecting lines

border the inside shapes

border the outer edges

A border design in which pairs of spirals are connected with a c-curve and joined with straight lines

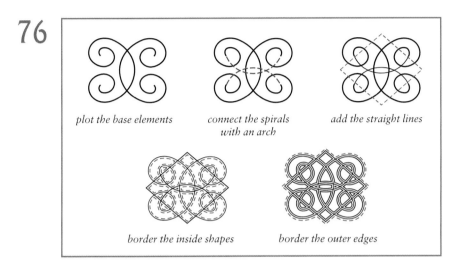

76

plot the base elements

connect the spirals with an arch

add the straight lines

border the inside shapes

border the outer edges

Ram's horn spirals are connected by interweaving additional straight and curved lines

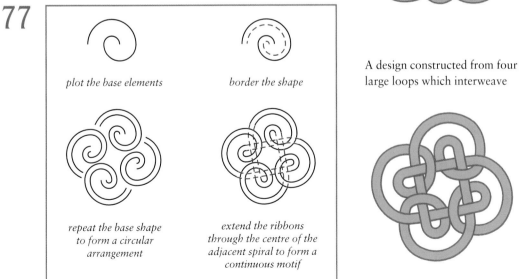

77

plot the base elements

border the shape

repeat the base shape to form a circular arrangement

extend the ribbons through the centre of the adjacent spiral to form a continuous motif

A design constructed from four large loops which interweave

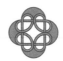

78

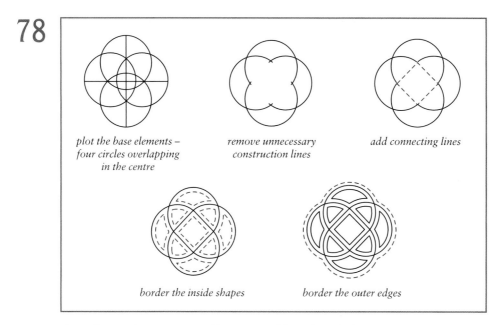

plot the base elements –
four circles overlapping
in the centre

remove unnecessary
construction lines

add connecting lines

border the inside shapes

border the outer edges

A continuous, interwoven motif constructed from four circles

79

plot the base elements – three circles
overlapping in the centre

remove unnecessary
construction lines

border the
inside shapes

border the
outer edges

This triquetra is constructed
from a base of three circles

80

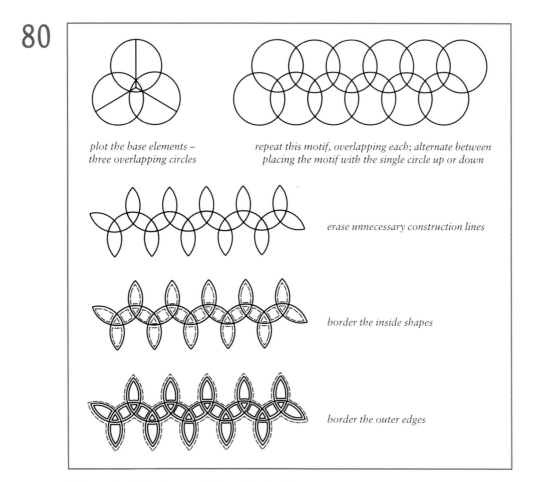

*plot the base elements –
three overlapping circles*

*repeat this motif, overlapping each; alternate between
placing the motif with the single circle up or down*

erase unnecessary construction lines

border the inside shapes

border the outer edges

This border design is a variation of Design 79

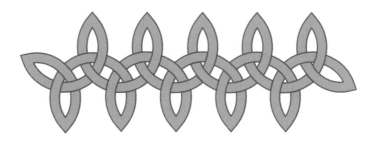

81

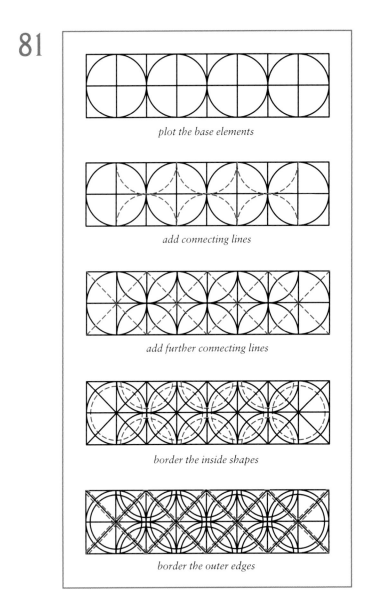

plot the base elements

add connecting lines

add further connecting lines

border the inside shapes

border the outer edges

A border design combining circles and half circles

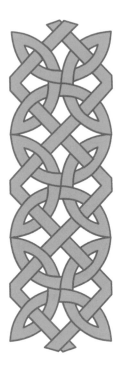

INTERWOVEN MOTIFS & BORDERS ·

82

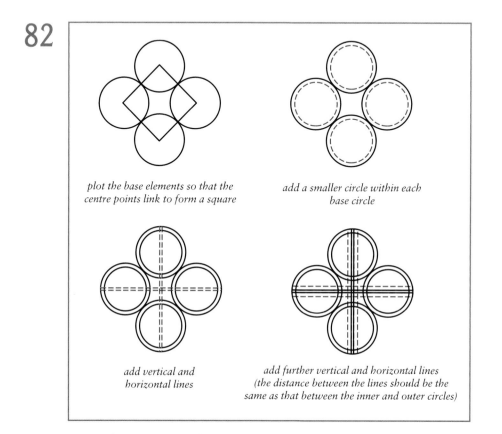

plot the base elements so that the centre points link to form a square

add a smaller circle within each base circle

add vertical and horizontal lines

add further vertical and horizontal lines (the distance between the lines should be the same as that between the inner and outer circles)

A cross design developed from circles and straight lines

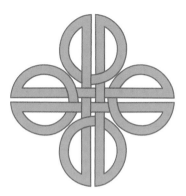

83

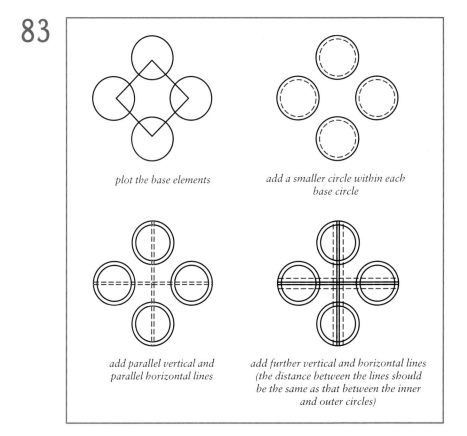

plot the base elements

add a smaller circle within each base circle

add parallel vertical and parallel horizontal lines

add further vertical and horizontal lines (the distance between the lines should be the same as that between the inner and outer circles)

A variation of Design 82 with the base elements plotted further apart

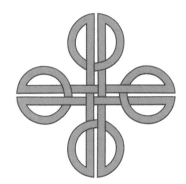

84

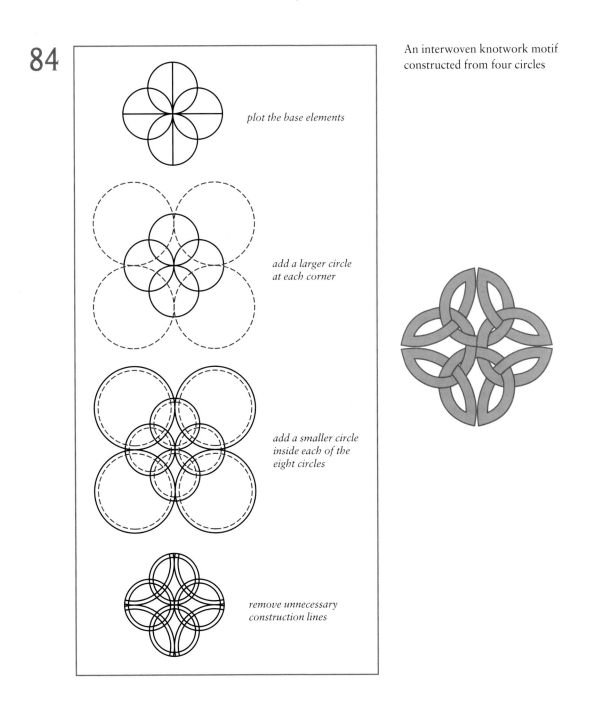

plot the base elements

add a larger circle
at each corner

add a smaller circle
inside each of the
eight circles

remove unnecessary
construction lines

An interwoven knotwork motif
constructed from four circles

85

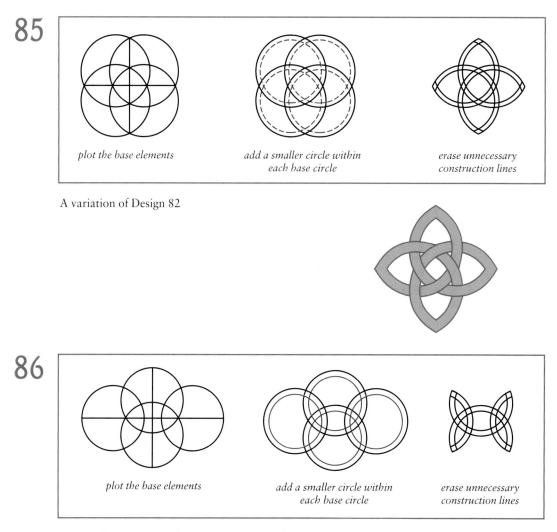

plot the base elements *add a smaller circle within each base circle* *erase unnecessary construction lines*

A variation of Design 82

86

plot the base elements *add a smaller circle within each base circle* *erase unnecessary construction lines*

Base circles are arranged to construct a small heart

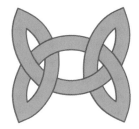

87

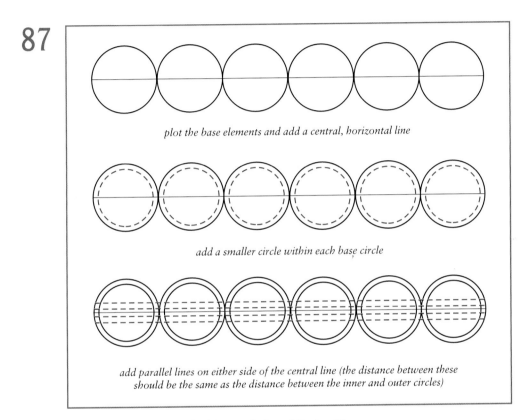

plot the base elements and add a central, horizontal line

add a smaller circle within each base circle

*add parallel lines on either side of the central line (the distance between these
should be the same as the distance between the inner and outer circles)*

An interwoven border which is a variation of Design 82

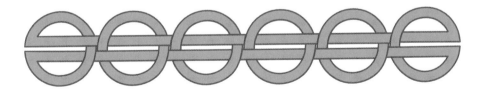

88

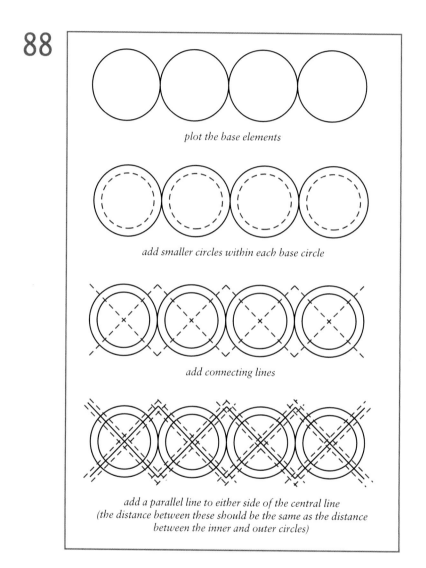

plot the base elements

add smaller circles within each base circle

add connecting lines

*add a parallel line to either side of the central line
(the distance between these should be the same as the distance
between the inner and outer circles)*

A border design in which circles are interwoven with straight lines

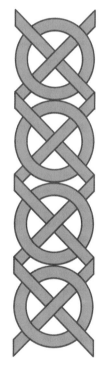

FRET, MAZE & KEY PATTERNS

Chapter 12

PLOTTING THE DESIGNS

◆

'Fret', 'maze' and 'key' are terms given to patterns constructed from diagonal and straight lines – all are characteristic elements of Celtic decorative art. Fret patterns developed from the earlier spiral patterns, over many years (see Fig 12.1). As with other Celtic designs, the 'paths' for all of these patterns must be kept a uniform width.

Any fret, maze or key pattern can be 'expanded' to produce an all-over design or panel by connecting further motifs to the exit points of those already plotted or placing additional 'strips' of the design above or below what has been plotted, as shown in Design 90.

These designs do not provide such opportunity for the use of colour as other Celtic designs; because the spaces are not closed off, there is no demarcation line between one colour and another and ribbons are not produced.

BASIC PLOTTING TECHNIQUES

The squares in Celtic art are usually a diamond shape, plotted at an angle of approximately 60°. A convenient method for learning to construct fret, maze and key patterns is to use graph paper for the plotting, and then to rotate the completed design.

Graph paper is essential for the successful plotting of fret, maze and key patterns, in order to keep a uniform size

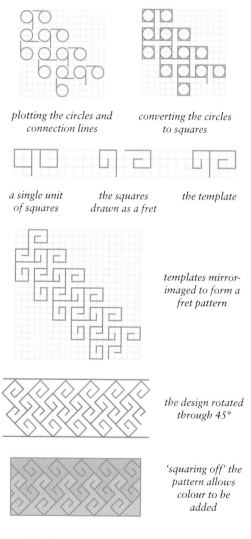

plotting the circles and connection lines

converting the circles to squares

a single unit of squares

the squares drawn as a fret

the template

templates mirror-imaged to form a fret pattern

the design rotated through 45°

'squaring off' the pattern allows colour to be added

Fig 12.1 Fret patterns developed from the earlier spiral designs

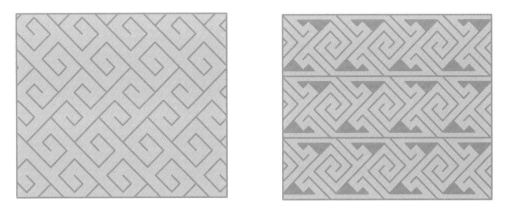

there are no 'stopping' places in these patterns, so they can only contain one colour

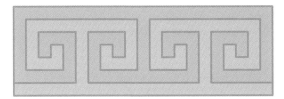

in this pattern, the centre is 'sealed', allowing contrasting colours to be used

Fig 12.2 There can be only limited use of colour in fret, maze and key designs

and shape. The grid sizes recommended for the designs in Chapters 13–15 refer to a single base element of each.

Fret designs

Frets can be regarded as 'square' spirals and can be drafted from spirals using the same exit and entry points as the circles plotted in the spirals section. For this reason, the equivalent base of circles for each design in Chapter 13 is shown, though this is not part of the plotting process.

For plotting fret patterns, follow the steps given below. Although not every pattern requires each step to be followed, the general process and order of plotting remains the same.

1 Plot the base of squares.
2 Plot the frets following these squares and/or add connecting lines.
3 Plot the repeating motifs.
4 Border the outer edges if desired.
5 Rotate the completed pattern.
6 Fill any spaces as required.

Three plotting techniques used in drafting fret designs are:

- ‹ 'opening' adjacent squares to produce an interlocking motif
- ‹ identifying the entry and exit points in a spiral pattern and using these to develop a similar fret design
- ‹ using grid paper for plotting the pattern and rotating this pattern to get the correct angles for a Celtic design

These techniques are illustrated in Figs 12.3, 12.4 and 12.5.

an 'open square', plotted here on a 5 x 4 grid, enables adjacent squares to interlock

the centres of interlocking squares can be left unconnected, or joined to make a single-line 'straight' spiral

Fig 12.3 Plotting a single, interlocking fret

the two exit points of the circles are retained when the border is converted to squares, then to a fret pattern

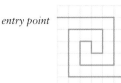

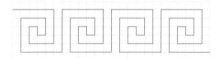

join the motifs together with a vertical line

add a border to the top and bottom to give a double ribbon

the ribbons are coloured to finish the design

Fig 12.4 Drafting a fret pattern following the entry and exit points of a spiral design

plot the base of squares

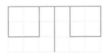

add connecting lines

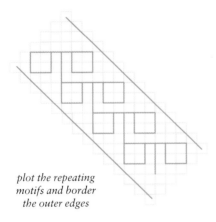

plot the repeating motifs and border the outer edges

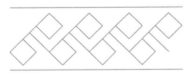

rotate the completed pattern

Fig 12.5 The process of plotting and rotating a fret pattern

Maze designs

Maze patterns are constructed from a collection of basic shapes (see Fig 12.6), which themselves are made up of straight lines. As the name suggests, these lines are plotted to form labyrinths. Diagonal lines and triangles are not used in the construction of maze patterns, although triangles are used to infill spaces in the finished designs. The basic method for plotting maze patterns is as follows:

1 Plot the basic shapes.
2 Connect with further lines and add solid shapes as required.
3 Border the outer edges.

The basic shapes are plotted so that they appear to intertwine. Sometimes no further steps are required in order to produce a basic maze pattern, though in designs where the width of the empty spaces varies, further lines and solid shapes must be added to fill in these spaces in order to keep the width even.

Key designs

Key designs are so called because the shapes within them resemble the notches of a key. Celtic key patterns incorporate diagonal lines in the designs – they are developed from a base that includes triangles. In order to keep the spaces within a design a uniform width, it is necessary to infill part of the triangles with additional short lines and filled shapes. It is the addition of the short lines that gives the impression of a key. The basic method for plotting key designs is the same as that followed for maze patterns:

1 Plot the basic shapes.
2 Connect with further lines and add solid shapes as required.
3 Border the outer edges.

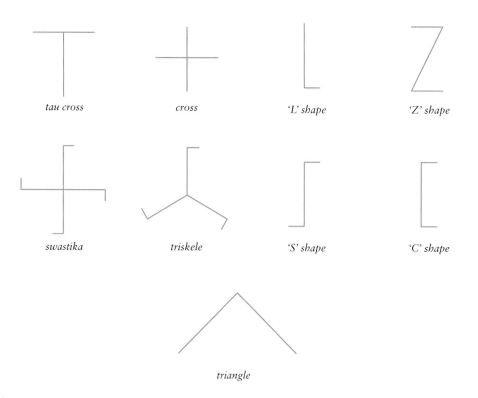

tau cross · · · · · cross · · · · · 'L' shape · · · · · 'Z' shape

swastika · · · · · triskele · · · · · 'S' shape · · · · · 'C' shape

triangle

Fig 12.6 The basic shapes used to construct maze and key designs – triangles are used only in key patterns

Chapter 13

FRET DESIGNS

◆

6 ACROSS X 3 DOWN

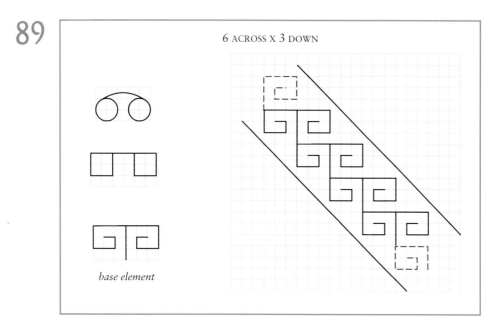

base element

This is the same design as that in Fig 12.4, with the squares drawn as frets. At the end of each border a half motif is used to fill the gap

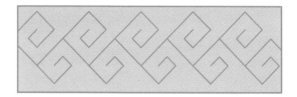

90

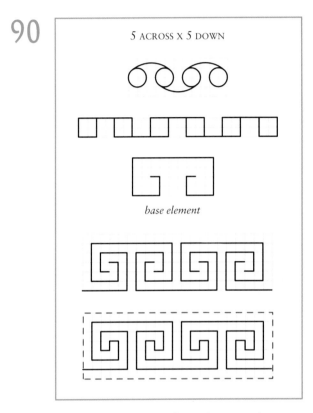

5 ACROSS X 5 DOWN

base element

A border arrangement of ram's horn spirals

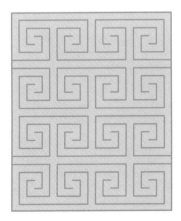

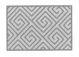
91

6 ACROSS X 3 DOWN

base element

A larger design constructed from a diaper pattern

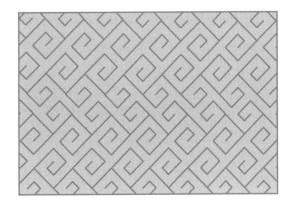

92

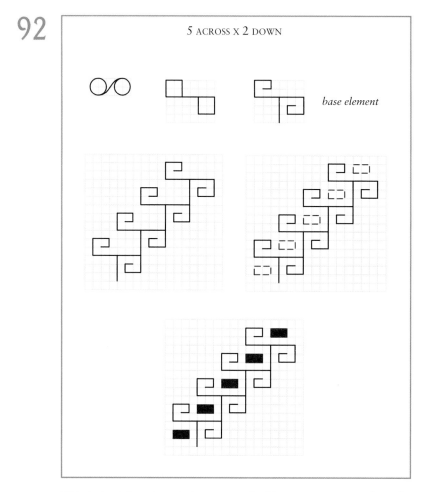

5 ACROSS X 2 DOWN

base element

This design is based on circles connected with s-curves, converted to a fret pattern by squaring off the circles and joining them with straight lines

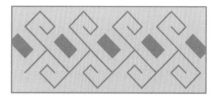

93

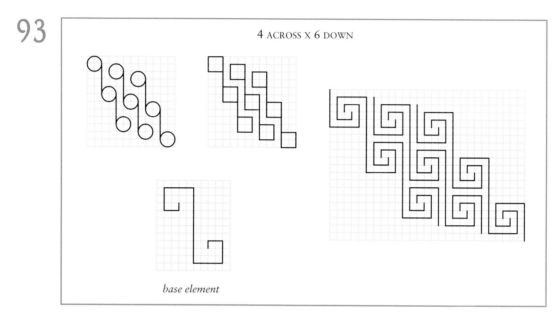

4 ACROSS X 6 DOWN

base element

Another example of a spiral design developing into a linear one.
This pattern is based on Design 42

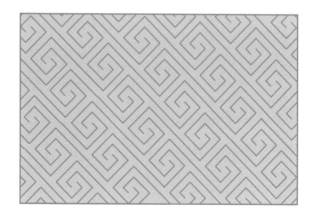

94

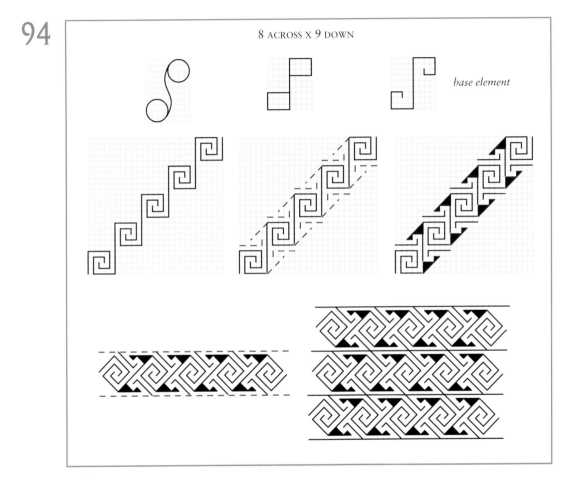

base element

A fret border based on the 's' shape

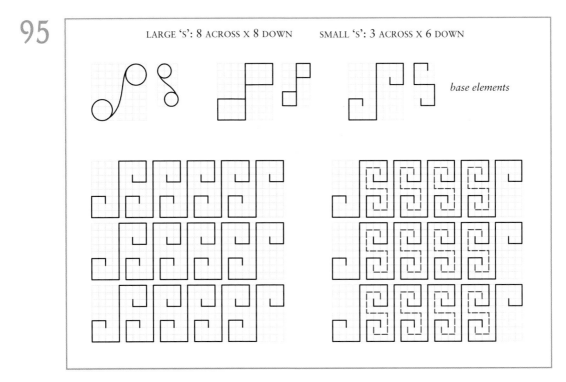

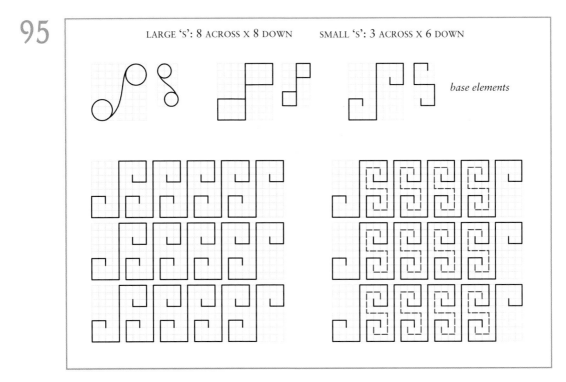

95

LARGE 'S': 8 ACROSS X 8 DOWN SMALL 'S': 3 ACROSS X 6 DOWN

base elements

A fret pattern constructed from two s-curves

96

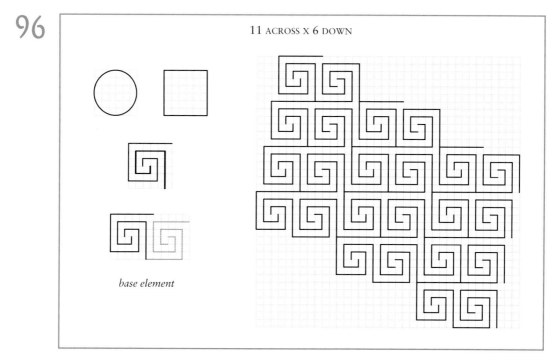

11 ACROSS X 6 DOWN

base element

A fret pattern based on an arrangement of circles. The
motifs are plotted in pairs, one turned at 45° to the other

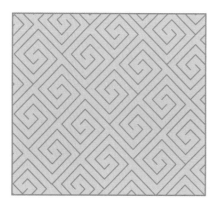

Chapter 14
Maze Designs

◆

97

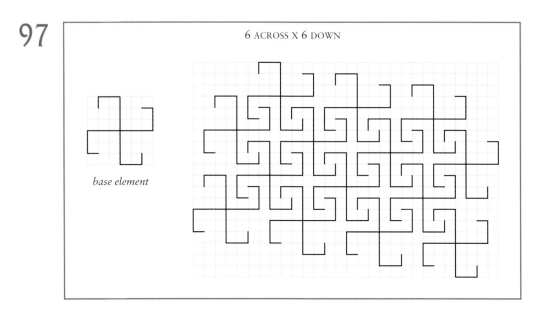

base element

A maze pattern based on the swastika

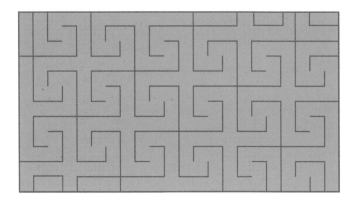

98

6 ACROSS X 6 DOWN

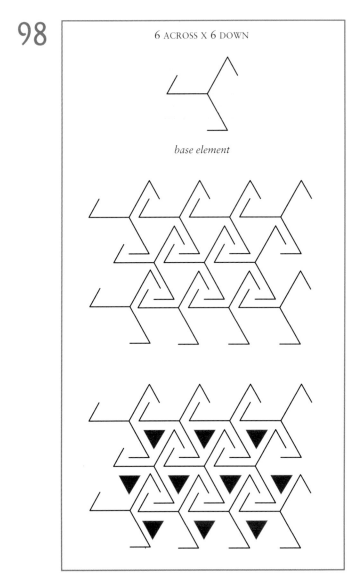

base element

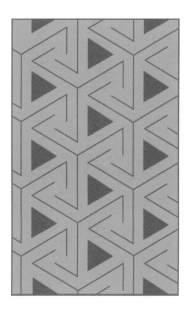

This pattern has been developed from a triskele. For clarity, grids have not been shown for the plotting of this design

99

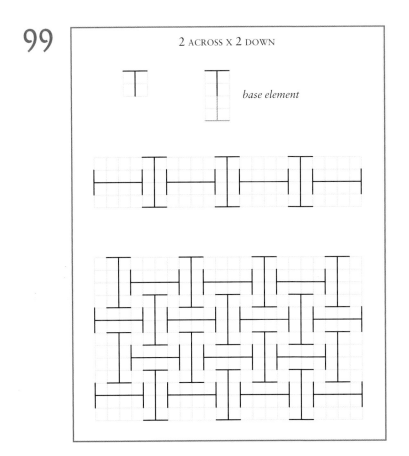

2 ACROSS X 2 DOWN

base element

The Tau cross is the basic shape for this pattern, with two joined end-to-end to form a single unit

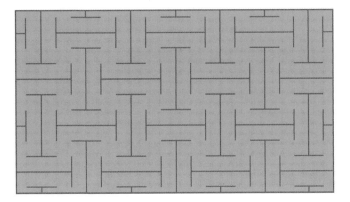

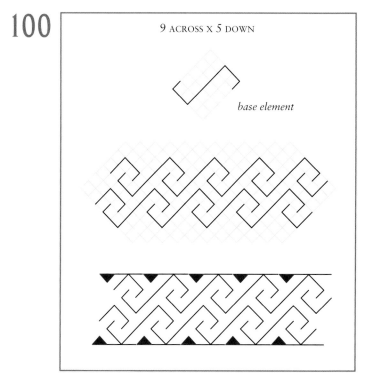

100

9 ACROSS X 5 DOWN

base element

A border pattern based on a hooked 's' shape

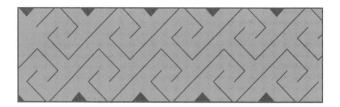

101

2 ACROSS X 3 DOWN

base element

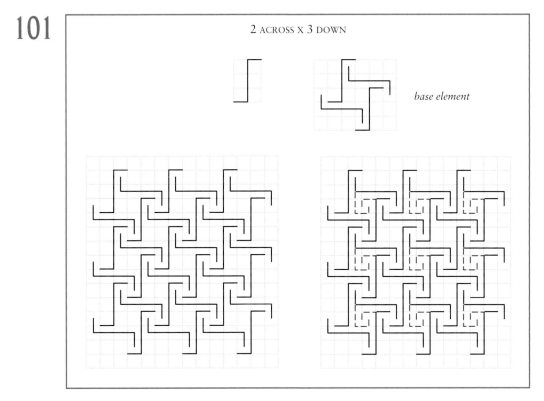

The 's' shape used to form a square pattern

Chapter 15
Key Designs

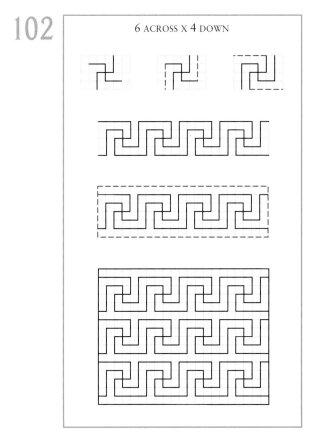

102

6 ACROSS X 4 DOWN

A key pattern constructed from a swastika

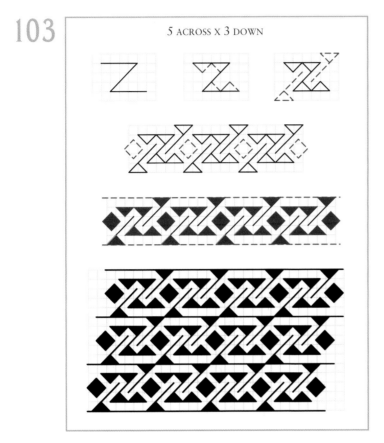

This pattern is developed from the 'z' shape

104

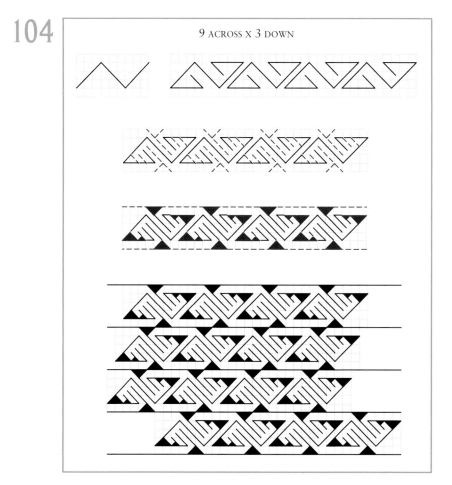

9 ACROSS X 3 DOWN

Similar to Design 103, this pattern is also developed from the 'z' shape

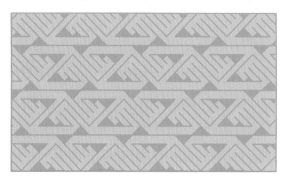

105

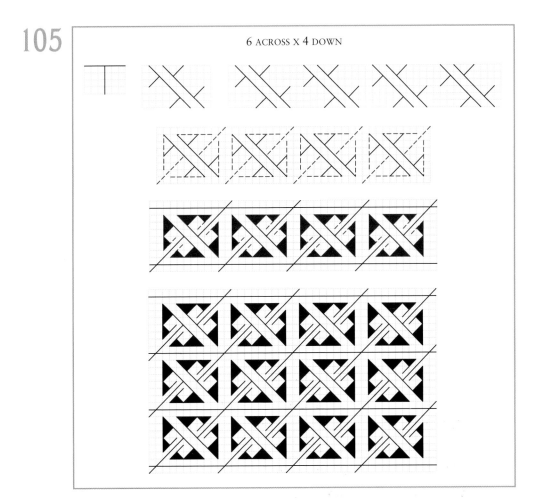

6 ACROSS X 4 DOWN

This pattern is based on the 'T' shape, plotted in groups of four consisting of two mirror-imaged pairs

106

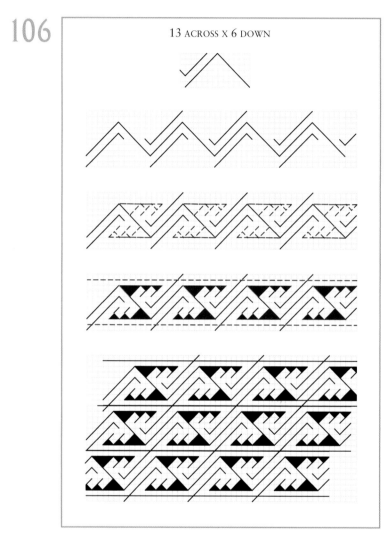

13 ACROSS X 6 DOWN

A key pattern based on repeating diagonal lines and 'L' shapes

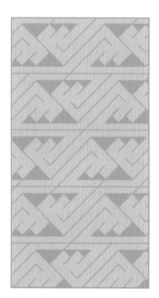

107

10 ACROSS X 5 DOWN

Another key pattern with a base of diagonal lines and 'L' shapes

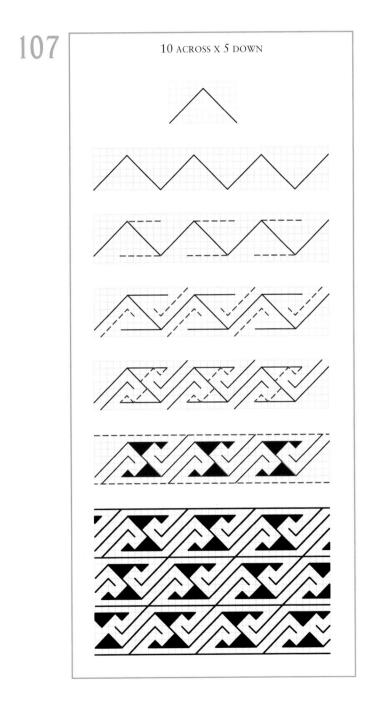

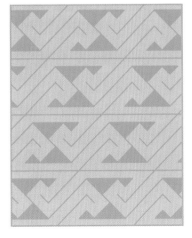

108

10 ACROSS X 11 DOWN

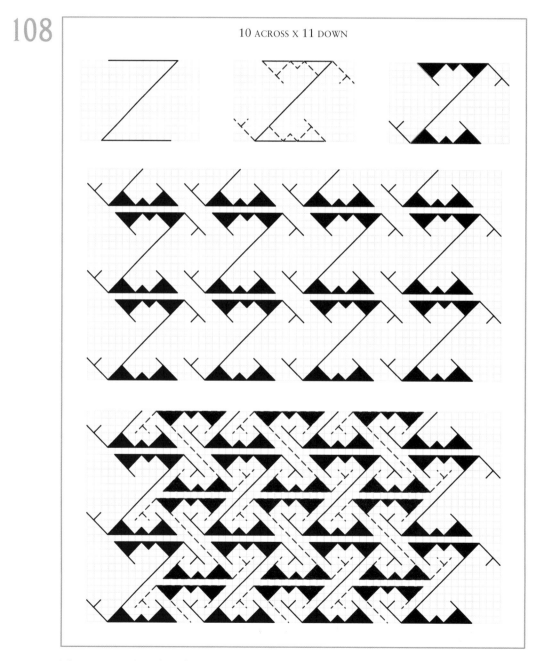

This pattern is based on the 'Z' shape

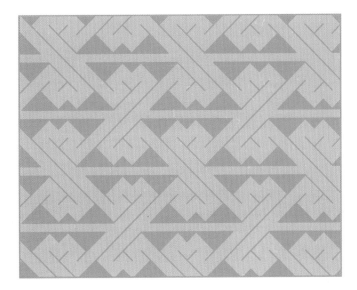

109

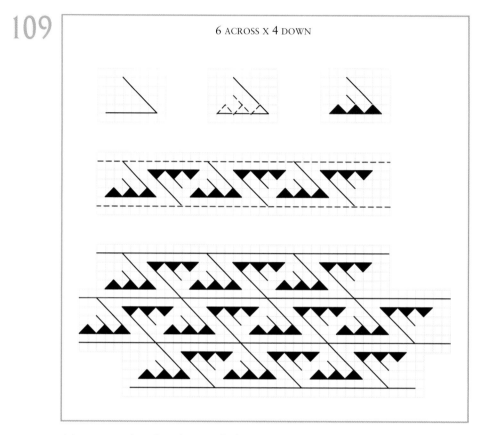

6 ACROSS X 4 DOWN

A key pattern based on the triangle shape

110

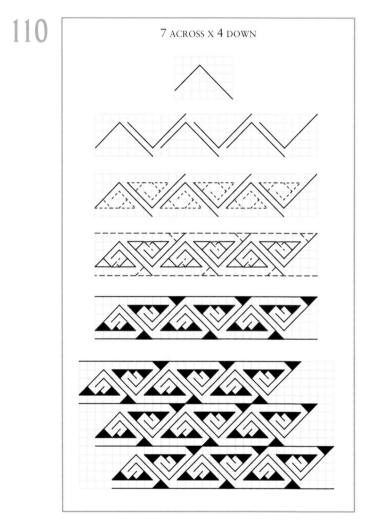

7 ACROSS X 4 DOWN

Both small and large 'L' shapes form the base
of this key pattern

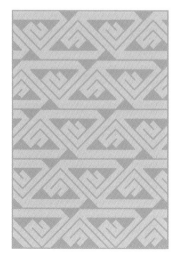

Zoomorphics, Anthropomorphics & Plant Designs

Chapter 16

Plotting the Designs

Celtic designs depicting animal, human and plant forms appear complicated because the eye is confused by the interweaving of the ribbons which embellish them. They are not as difficult to construct as they look, being developed from basic loops, s-curves and occasionally straight lines.

The designs in Chapters 17 and 18 are not based on a number of squares but drawn freehand, so grid sizes have not been recommended.

Zoomorphics

In zoomorphic designs the bodies themselves are stylized and generally bear no resemblance to any living animal. The main part of the body is the thickest section of the design, while limbs taken off the body taper towards the feet and are often used to connect motifs into larger designs. The spaces within the body cavity and around the animal can then be decorated with narrow ribbons extended from the ears, tongue, tail or feet. This decoration can be a simple line or an unstructured ribbon which not only weaves over and under the body but also around itself. The limbs of animals depicted in zoomorphic designs are all available for interweaving, and the points where these limbs attach to the body are frequently drawn as spirals. Any wide body parts can be further decorated, allowing greater use of contrasting colours in the design.

Anthropomorphics

The Celts believed that the head was the resting place of the immortal soul and that if they kept the head of an enemy, they would have control of his spirit. In motifs depicting the human figure, in which a downturned mouth and staring eyes are typical, the head is affixed to one end and the other is divided to form legs. Characteristic elements of these designs are the long beard and hair from which additional ribbons are taken, either to connect figures or to decorate the loop of the body. In many human designs, the arms and legs are interlaced. Anthropomorphic designs are often arranged as a swastika, and may include bird and animal motifs.

Cormac's *Missal*, which was produced in the latter part of the twelfth century, contains designs connecting human and bird's heads with multiple interwoven lines. These designs are coloured in shades of green, purple, blue and yellow on a red background.

Plant designs

Plant forms, particularly the lotus flower, were the earliest form of decoration in Egypt and France. Plant patterns constructed from interlocking scrolls and spirals were probably developed from Egyptian plant designs. Basic designs can be skilfully developed into border patterns and motifs, and may interweave birds, animals and vines with the scrolls.

The palmette, a fan-shaped group of leaves frequently used as a border design, was introduced to Egypt around 3000BC; Greek

a basic 'leaf' loop

border palmette with two-exit spirals

border palmette with a double spiral

plant cornucopia developed from a loop

plant motif constructed from four single spirals

Fig 16.1 Typical Celtic plant borders and motifs

designs combined the acanthus leaf and the lotus flower. While the classic acanthus is ignored, both the palmette and the lotus flower are found in early Celtic ornament, along with the lyre pattern, constructed from two s-curves.

Designs are concentrated on plant patterns with leaves which closely resemble an arabesque. Curves and scrolls weave together on either side of a central stem and often terminate in a spiral as in the cornucopia shown above.

The vine has a theological significance (John 15: 1–17). The Syrian vine border, used in Italy during the second century AD, can be found on crosses in the north of England. Examples of typical Celtic plant designs are shown above.

BASIC PLOTTING TECHNIQUES

As drawing zoomorphic designs allows more room for freehand variations than the designs in the previous chapters, the plotting shown in Chapters 17 and 18 is not strict step-by-step, but just to give a general idea of the process involved. Experiment by drawing curves and then adding limbs; these should leave the foundation loop in a graceful curve. Taper the legs before adding the feet, and widen the section of loop that represents the body. Decorate the shoulder joints with the addition of spirals.

Lay-out paper is ideal for designing zoomorphics and anthropomorphics: it eliminates the need to trace prior to inking in as designs can be transferred directly by tracing in ink over the template. It is also helpful for trying out borders and motifs which combine two or more figures.

The essential factor in combining designs which interweave is to identify a suitable position for the motifs to connect. Determine the shape of the animal, ink over the outline and use a piece of lay-out paper to trace over this template. By placing this second outline over the first, the shapes can be moved into various positions until a satisfactory connection is found. You may need to enlarge the body or change the shape of a curve to fit the pieces of the animal together.

Make these amendments to the tracing on the lay-out paper. When you're satisfied, ink in the amended outline. This can now be used as the template. Place it under a sheet of lay-out paper and trace over it in ink; if you plan to add further decoration, trace over it in pencil

at this stage to allow for the correct interweaving of additional ribbons. By moving the template into the required position, the design can be repeated accurately to form a border.

Do the same to determine a satisfactory path for any decorative ribbons. Ink the ribbons in and place this template under the border template, which, at this stage, should be in pencil. Trace over the ribbons and determine the correct pattern of interweaving. When you are happy with this, ink in the completed border design.

Terminal motifs

The ends of knotwork ribbons are greatly enhanced by the addition of endings in the form of animals, humans and plants. The examples below show some useful methods of incorporating these.

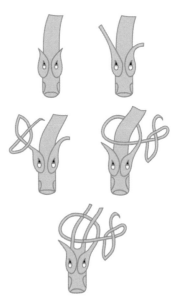

Fig 16.2 Variations on the basic snake's head

Snakes

Snake patterns are knotwork patterns to which a head and tail are added as terminal endings. Snakes always retain the same basic shape, varying only according to the fancy of the artist – some may use larger eyes or have deeper curves around the mouth, but there is little difference.

Birds

HEADS

There are two main types of head; one based on the cormorant (or shag) and the other based on the eagle. The cormorant has a long beak and long legs, which are useful for connecting motifs, while the eagle has a short, hooked beak and strong feet. Ribbons can be extended from the head for further embellishment or connecting with other motifs.

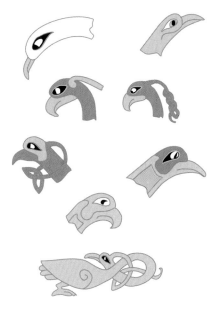

Fig 16.3 Common shapes and methods of embellishment for bird's heads

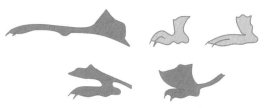

Fig 16.4 Variations in toe and leg shape for bird's feet

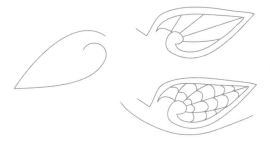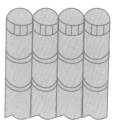

Fig 16.5 Adding feathers to the basic body shape

Fig 16.6 Alternative feather patterns

Feet

There are many options open for feet. Generally, long pointed toes are used with the cormorant heads and short, hooked feet with the eagles. The heel of a bird can be extended to decorate a single motif or to connect motifs. Extending the leg itself is another means of connecting motifs and filling in spaces.

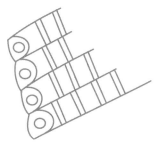

Bodies

The body is usually the shape indicated in Fig 16.5, and with the centre part decorated with feather patterns. This affords the opportunity of adding contrasting colours to the design. The feathers should be kept a uniform width. Draw in light construction lines before completing and decorating the feathers.

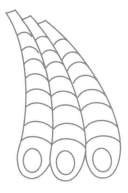

Tails

These can be short and straight or long and curved, the latter being useful for connecting motifs. Patterns in the tail feathers again provide an opportunity for adding contrasting colour to a design, and left plain, add interest to a black-and-white design.

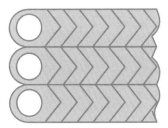

Fig 16.7 Tails can be short or long, straight or curved

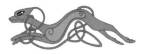

Chapter 17

Zoomorphics & Anthropomorphics

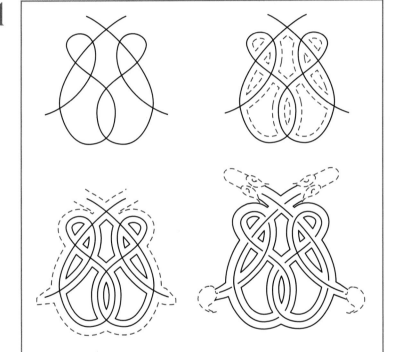

Interlaced knots finished with a snake decoration

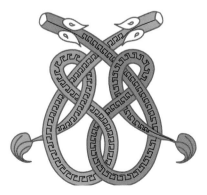

112

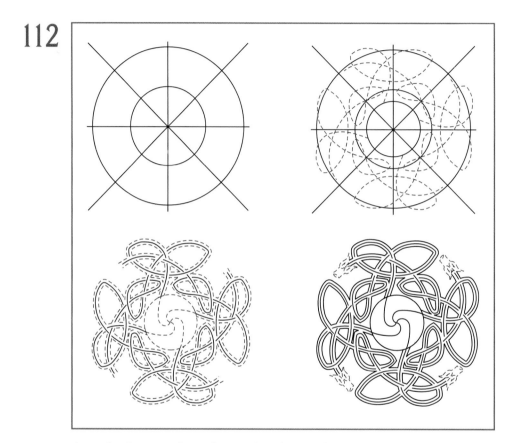

A circular design combining knotwork with a spiral centre. The basic heart shape has been used, with the top of each extended to fill the space available. Four ribbons interweave, with one end of each terminating at the centre of a four-exit spiral and the other weaving through the adjacent ribbon to end in a snake's head

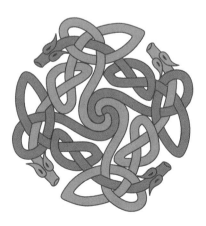

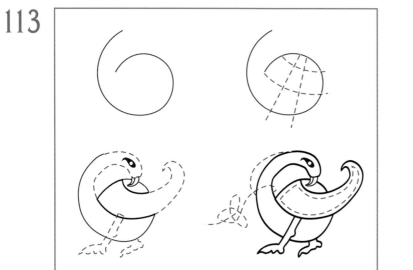

113

A basic bird developed from a single loop. The head is
attached to one end of the loop and the body to the other

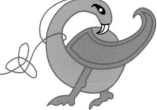

VARIATIONS

The same design plotted as a mirror-image
motif and to form a border. In the border the
long, slim leg is interwoven with an extension
from the foot, which is also used to fill in the
space between motifs. Long, curved tail
feathers balance the design

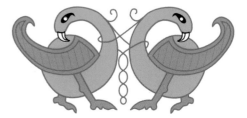

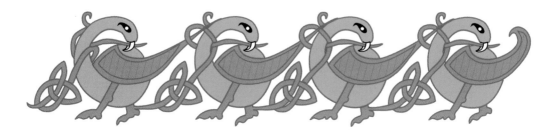

114

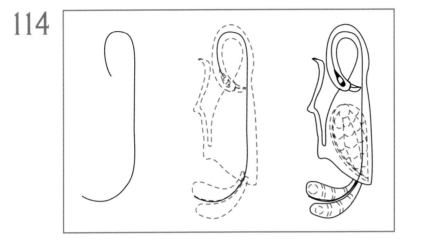

This design is finished with a ribbon interwoven around the neck and legs of the bird

VARIATIONS

The same design plotted as a mirror-image motif and to form a border

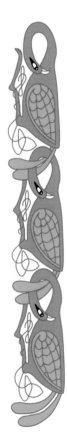

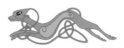

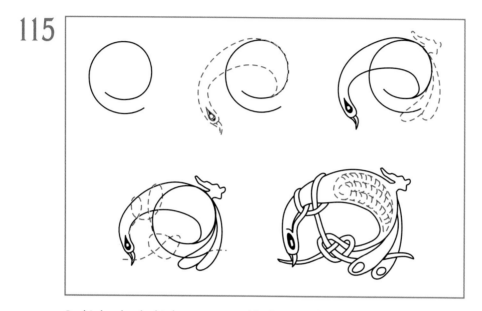

In this border the birds are connected by interweaving a
head through the tail feathers of the adjacent bird

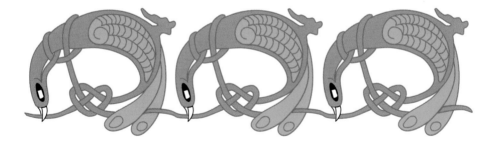

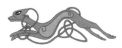

116

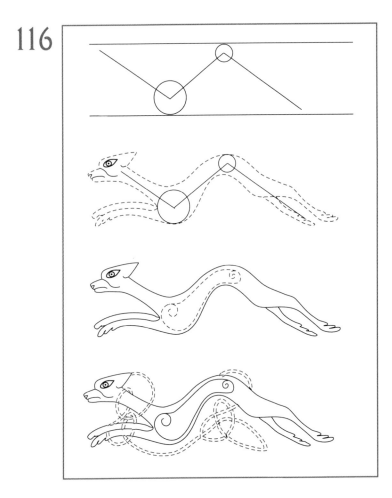

This dog is based on three straight lines, drawn with equal inside angles. These lines, along with the circles placed inside the lines, are used as construction guides for drawing the body (the lower circle is twice the size of the upper circle). A ribbon is taken from the ear and woven round the neck and front limbs before being taken under the body to form a knot below the belly, then passed behind the leg to join the tail. The panel in the centre of the body allows colour contrast to be added to the design

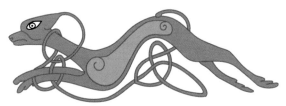

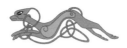

117

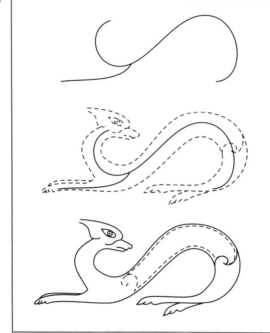

This motif is based on an s-curve. The front legs are extended from this in a shallow curve, the head is added to the smaller curve, and the larger curve is widened to form the body. For decorative purposes the joint of the back leg is indicated with a small spiral. As with Design 116, further decoration is added to the body by extending a ribbon from the back of the ear

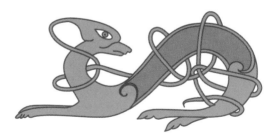

118

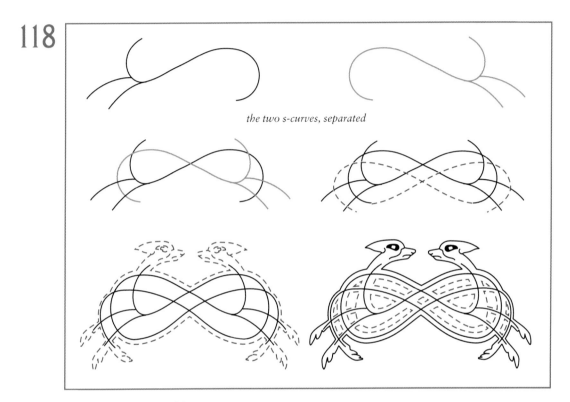

the two s-curves, separated

This motif is constructed from two s-curves, one the mirror image of the other. The 's' here is longer than in Design 117 to allow the two curves to interlock easily. Long front limbs are extended from the smaller curve. The end of the larger curve represents the back leg, which is extended to pass around the neck and to interweave with the front legs – there is only one back leg on each dog. Tongues are extended to fill the space between the heads

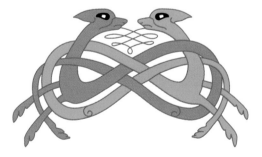

119

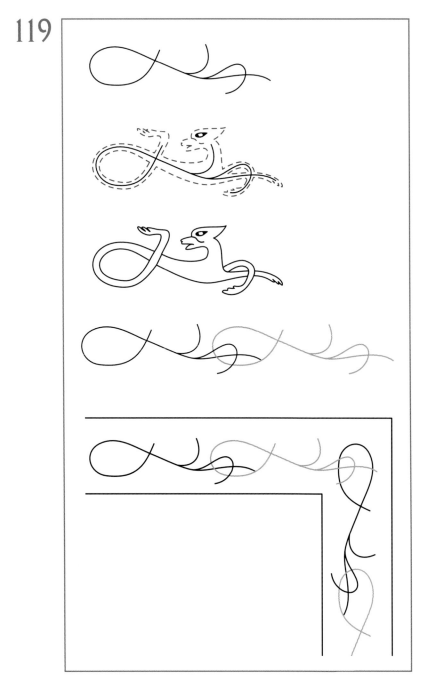

A border pattern in
which dog motifs are
connected by weaving
the front legs of one
through the loop of
the body in front. An
extension from the ear
is used to fill the spaces

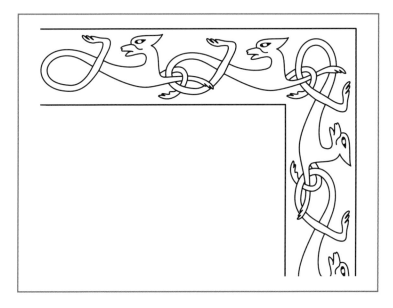

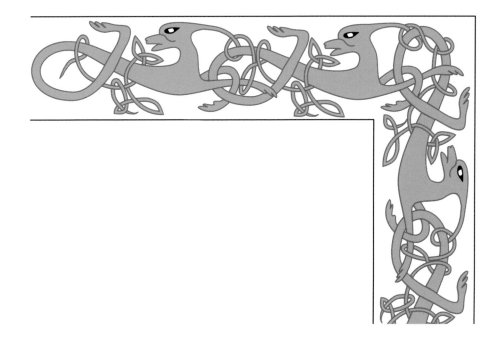

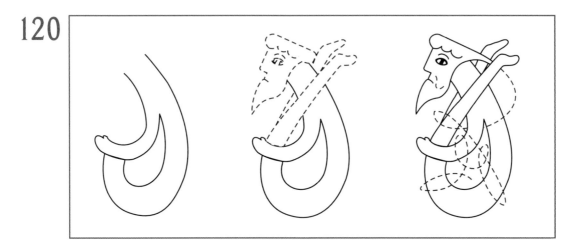

120

A human figure constructed from a simple loop. The arm is extended from the point below which the two ends cross, a head is attached to the end of the loop above the arm, and the other end is divided to provide two legs. In this classic pose, an extension is taken from the hair to fill in the space of the loop. This extension is bordered to provide a thin ribbon

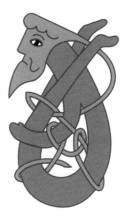

Chapter 18

PLANT DESIGNS

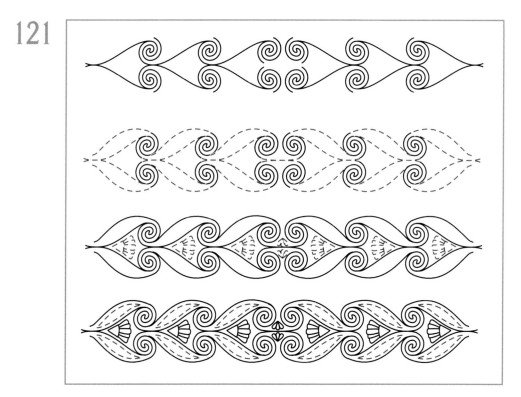

A border design with two-exit spirals and palmette decoration.
This design can be extended to any length, with the central motif
appearing at regular intervals or in the centre only

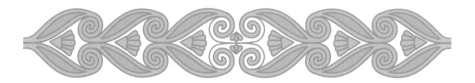

122

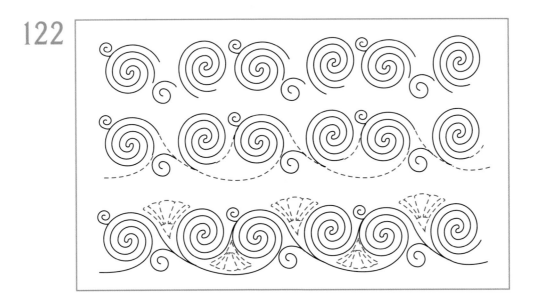

A plant border with palmette and spiral decoration

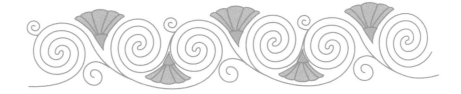

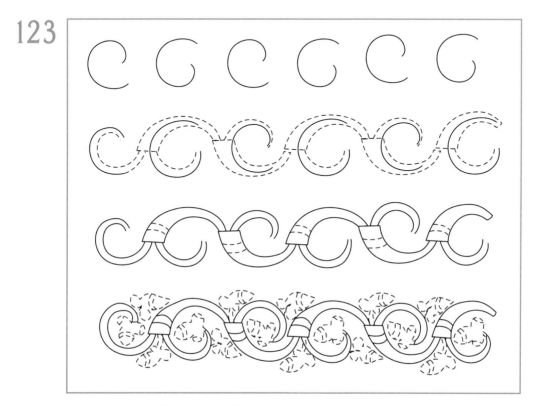

123

A simple plant border constructed from loops

124

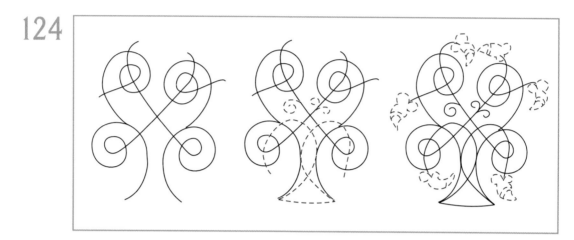

This plant motif is constructed from four spirals. The lower spirals are extended diagonally through the centre to exit through the upper spirals. The ends of the upper spirals are extended to exit through the sides of the design. Additional loops from the base of the motif cross in the centre and exit through the lower spirals. The free ends are then decorated with leaves, and additional loops are extended from the centre lines

PART THREE

Adaptations & Decorations

Chapter 19

Colour & Pattern in Celtic Designs

---◆---

Much of the colour and pattern in Celtic decoration comes from the embellishment used to fill the spaces of the design and to follow the paths of the ribbons.

Colouring ribbons

Take care when colouring spiral ribbons, particularly in complex designs, where there may be a problem with one ribbon weaving into another of the same colour. To avoid confusion, trace over the ribbons in contrasting colours to find the path of each. Any such problems can then be resolved before embarking on the actual design.

Interest can be added to the inside shape of a spiral by dividing the ribbon at the central meeting point and filling each division with contrasting colours. The motif in Fig 19.1 combines this technique with the addition of a trumpet spiral decorated with a plant motif.

base loop and spiral *the spiral is divided*

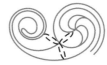

a plant motif is added *the construction lines*
for decoration *are removed*

the divisions are filled with colour

Fig 19.1 Interest can be added by dividing the ribbon to add contrasting colours

Colouring tips for ribbons

1 Try out colour combinations before embarking on the actual ribbonwork.
2 Try unlikely colours together for a dramatic effect.
3 Do not use colours which are very close in shade, as one tends to kill the other.
4 Be careful with dark colours; try them out before using them on the actual design as they can obscure the paths of

the ribbons and, where ribbons are interwoven, hide the crossing points. For this reason, dark colours are better used with a light border on either side of the ribbon.
5 Note carefully how many ribbons are in a design and work on one ribbon at a time: it is very frustrating when you find that you have coloured part of a different ribbon by mistake.

Successful colour combinations

TWO COLOURS
Poppy red and dark green
Orange and violet
Azure and red
Yellow and dark blue
Carmine red and emerald green
Gold and pale blue
Black and flesh colour
Black and red

THREE COLOURS
Red, yellow and dark blue
Light orange, black and azure
Light flesh colour, dark green and purple
Brown, light orange and purple
Dark brown, orange and dark blue
Crimson, light yellow-green and black

FOUR COLOURS
Photo black, light green, red and gold
Poppy red, dark green, grey-brown and black
Sienna, dark blue, light red and black
Ultramarine, cinnabar, green-bronze and lilac

additional construction lines plotted at 60°
to each other. Three of these are used to
position the spirals and three are used to
plot the trumpets.

*the motif is constructed
from two two-exit
spirals, one large and
one small, connected
with an arc*

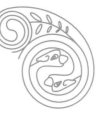

*the central area under
the arc is divided and
decorated, and dogs'
heads are drawn to
fill the centre of the
large spiral*

Fig 19.2 A dog motif constructed from two spirals

Filling spaces

There are many elements that can be used
to fill spaces in Celtic designs. The heads
of birds and animals can be used to
decorate the centres of spirals, and spaces
between spirals are often filled with plant-
type decoration based on the trumpet
pattern. The motif shown in Fig 19.2 is
constructed from two spirals connected
with a c-curve; Fig 19.3 is a variation of
the same design. Plant decorations have
been used to fill the spaces in Fig 19.4.
It is constructed from three spirals
connected to a three-exit centre, with

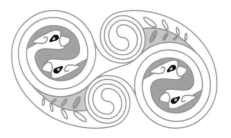

*the central area under the arc is divided and
decorated, and dogs' heads are drawn to fill the
centre of the large spiral*

Fig 19.3 An elaborate variation of the design in Fig 19.2

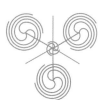

*locate the
connecting points*

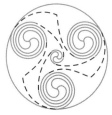

add connecting lines

*a head is added to fill the central space
of the spiral, and a body added to fill
the space between spirals*

*border the outer
shapes*

border the inner shapes

detailing is added to the bird motif

add decoration

the finished design

the motif is repeated to fill the remaining spaces

Fig 19.4 A boss design in which the spaces
between the spirals are filled with plant motifs

Fig 19.5 With a body, head and legs that can be
added to different parts of a design, a bird is a
versatile motif for filling any spaces in a design

The body of a bird can be used to fill the
spaces in a spiral design, as shown here in
Fig 19.5. Add a head to the centre of a
spiral, and fill in the space with the body.
Legs are excellent for filling any narrow
spaces in a design.

The ends of spirals can be finished
decoratively by bringing the ribbons
together and weaving them into a knot.
The example in Fig 19.6 shows two-exit
spirals ending in a single ribbon which
then branches and interweaves before

entering the spirals on the opposite side. Figure 19.7 shows a variation of the motif in Fig 19.1, in which the ends of the spirals are finished with knotwork.

spiral decorated with plant motifs

Fig 19.6 Decorative knotwork can also be used to fill spaces

centre decorated with scallop filling

Fig 19.7 A development of the motif in Fig 19.1 in which the ends of the spirals are finished with knotwork

centre decorated with cross hatch shading and outer shapes filled with bird motifs

Fig 19.8 The background of spiral designs can be filled with various types of decoration; a selection are illustrated above

Background textures

A bold effect is created when the background is blackened and the design left uncoloured. Alternatively, the background may be shaded or marbled, or filled with stone or grain patterns. Stoning is achieved by completely filling the background with small dots (rather like sand), and graining by 'taking a line for a walk'. Graining produces an indeterminate pattern. Small lines can be placed to produce a pattern of fretwork, scallop shells or feathers, and larger background areas can be filled with a plant or zoomorphic decoration.

A favourite method of decoration in *The Lindisfarne Gospels* was to outline a design with a series of small dots in a

contrasting colour. Small circles can also be used in this way to fill in backgrounds. Because there is more space to fill in spiral backgrounds than in knotwork and other designs, there are many more possibilities for experimentation and variation. Some ideas are shown below, all of them used to fill a Celtic dragonesque brooch shape.

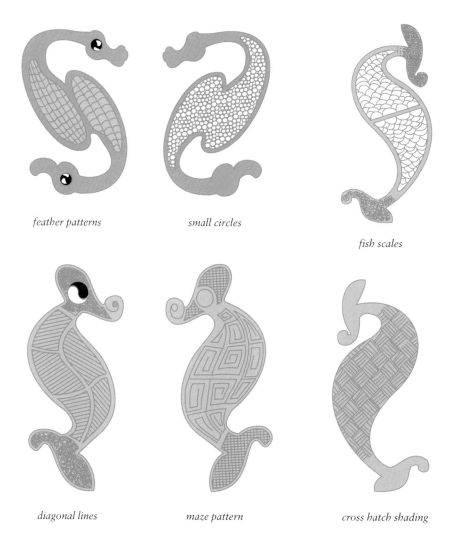

feather patterns *small circles*

fish scales

diagonal lines *maze pattern* *cross hatch shading*

Fig 19.9 Examples of different background textures

Chapter 20

Using Celtic Designs in Other Crafts

Appliqué

The word appliqué is taken from the Latin verb 'applicare', meaning 'to fold' or 'to fasten to'. Originally, the technique was used to repair or strengthen fabric, but by the Middle Ages it had developed into an art form and was widely used to decorate ecclesiastical banners and wall hangings.

The fabric to be applied for decoration is first bonded to special adhesive-backed paper and the design drawn or traced onto this paper. The motif can then be cut out, the backing paper removed and the motif bonded to the background fabric. The appliqué can be finished either with overlocking stitches, using a machine, or with decorative hand-embroidered stitches.

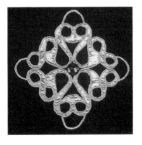

Fig 20.1 Padded gold lamé appliqué

For this piece, gold lamé was stabilized with Bond-a-web and machine appliquéd to a cerise background fabric, padded with a layer of wadding.

Batik

Decorated on both sides, this cushion explores and experiments with the free use of the spiral pattern and fillings to develop an all-over pattern for the fabric. Wax was used as a resist, and the fabric then painted with colourful fabric dyes to create a lively, fun piece.

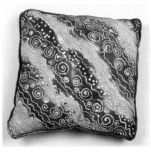

Fig 20.2 Free design, using spiral patterns and fillings

Fig 20.3 One big spiral fills the back of the cushion

Calligraphy

The word 'calligraphy', meaning 'beautiful writing', is derived from the Greek words 'kalle' and 'graphe'. Writing is a form of drawing, and the twenty-six 'symbols' that make up the English alphabet can be arranged in many different ways, with variations in composition and shape.

Fig 20.4 Spiral motifs decorate this illuminated manuscript

Fig 20.6 A simple spiral is used to fill the body space of this decorative bird

Fig 20.5 Spirals developed into border designs mark the boundaries of this text

Fig 20.7 Spirals are carried through the body and tail of this fish

Cross stitch

Cross stitch is a form of counted thread work and as such, is applied to fabrics woven with the same number of threads per inch in both warp and weft. Each stitch is worked over a regular number of threads, covering a small square of fabric.

Patterns are usually worked out on graph paper, with each square of the paper representing one stitch. The effect is quite stylized, especially in the case of small motifs, as curved lines must be adapted to conform to the straight lines of the graph paper and fabric threads. This is the most difficult aspect of representing Celtic designs in cross stitch. (See Adapting curves and rounded corners, page 166.)

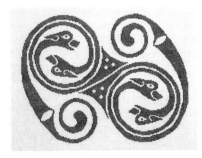

Fig 20.8 An example of zoomorphics, with stylized dogs' heads used to finish the ends of these spirals

Fabric painting

Simple, effective designs can be worked by painting knot outlines directly onto fabric and interlacing them with surface embroidery stitches. This design was used to decorate the ends of a stole, with the background painted in gold and the outline embroidered in gold thread.

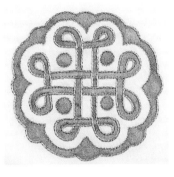

Fig 20.9 The outlines of this design are defined with gold thread

Hardanger embroidery

This embroidery is usually worked in white or cream on the same coloured background. The box shown used the technique as a means of showing the coloured background with the spirals in the foreground. Kloster blocks are worked round the shapes before threads are cut and withdrawn. Each block consists of five stitches; four of the threads are to be cut out and the remaining threads overcast together. The cord for

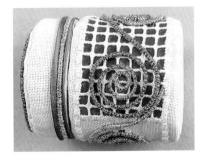

Fig 20.10 Embroidered, single-exit spirals decorate this fabric-covered box

the spirals was made by overcasting a cotton thread with various colours of gold and variegated silk threads on the sewing machine, and was couched into place. All the embroidery was done before the box was constructed.

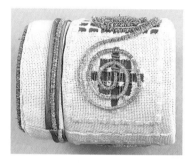

Fig 20.11 The darker background highlights the spiral design

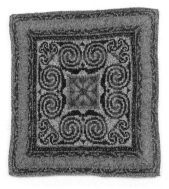

Fig 20.12 Ram's horns and multiple-exit spirals have been used to build up this knitted pattern

Knitting

When knitting Celtic knotwork and spiral designs, it is essential to work a tension square first – at least 2.5 x 2.5cm (1 x 1in)

– in order to establish how many stitches are required across and down to form an exact square. Use contrasting colours for plotting the pattern on a grid; these colours need not be the same as the wool to be used, but should be easy to follow.

In this knitted panel, the inner section is composed of four pairs of ram's horns surrounded by a narrow rope border. The outer border is a combination of two- and three-exit spirals.

Lace

True lace has been made since the early sixteenth century. The two main types of handmade lace are needlepoint and bobbin lace. Needlepoint lace tends to be stiffer than bobbin lace.

Needlepoint, or point lace, is made, as the name suggests, using a needle. The stitch used is buttonhole stitch. The pattern is defined with a cordonnet (outline) of thick cotton.

Bobbin lace, also known as pillow lace, is made using threads wound round a bobbin. The challenge in creating a knotwork design in bobbin lace is to keep the lacework as one continuous piece, with no sewing in the lace.

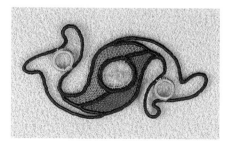

Fig 20.13 The centre of this needlepoint design elongates the basic yin/yang symbol

Fig 20.14 Needlepoint lace used in jewellery

Pyrographed Celtic designs are relatively easy to achieve. The chosen design can be traced onto the wood or other material, in pencil, and this outline can then be traced over with the heated poker.

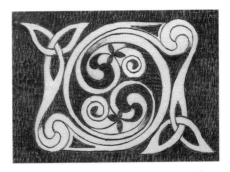

Fig 20.16 Plant motifs fill the spaces in this pyrographed spiral design

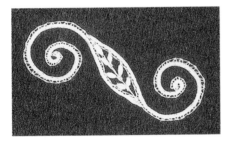

Fig 20.15 A spiral design created in bobbin lace

Pyrography

Pyrography, burnt-wood etching, and poker work are all names by which the art of burning designs onto materials is known. The term pyrography was coined by the Victorians, taking the Greek words 'pûr', meaning fire, and 'graphos', meaning writing. The craft has been practised all over the world in one form or another, almost certainly since man discovered how to make fire.

Quilling

Quilling, or paper filigree, was probably inspired by metal filigree, in which gold and silver wires are used to create intricate and delicate designs. It is thought to have originated over 500 years ago, but little of its history has been recorded, and the quillwork preserved in museums dates from the late eighteenth or early nineteenth centuries, a time when paper became less costly and therefore, more readily available.

It is not easy to make quilling precise, and illustrating Celtic designs using quilling techniques presents two main problems. The first of these is obtaining the very fine outlines that are essential to Celtic designs. In the design shown on page 164, tight circles of black quilling paper were glued in an upright position all around the outer and inner lines.

The second is maintaining the symmetry that is integral to so many Celtic designs. This, combined with the clearly defined spaces to be filled, limits the number of quilling techniques that can be employed, but colour and other materials, such as beads, shells and pressed flowers, can be used to compensate.

Fig 20.17 Metallic threads and paper are combined in this quilled mask

Fig 20.18 This fish, in watercolour, combines Celtic knotwork and spirals

Watercolour

This fish was an experiment in using knotwork as an integral part of a watercolour design. A basic spiral design was used for the eye. The finished piece was outlined using the traditional decoration – a series of small dots.

Tatting

Tatting lends itself to spiral designs – the chains naturally form a curve as they are being worked. To give more stability to a design, the tatting can be worked over a covered wire, which can then be bent into shape when the chain is finished.

The design shown below was worked completely in reverse rings, with a pearl bead inserted at each interlaced point. The chosen tatting technique must allow the work to be flexible.

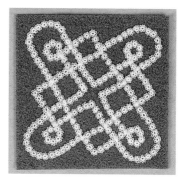

Fig 20.19 Unlike knitting and cross stitch, tatting lends itself to curves

Machine embroidery

To achieve the intricate lines of Celtic designs, this image was first traced and transferred to the back of the base fabric. The main shapes were then stitched to the

Fig 20.20 The different materials used in this panel add to the texture of the finished piece

Fig 20.21 An embroidered interpretation of a border from the *Book of Durrow*

background fabric using the traced lines as a guide, before removing the excess fabric from the front. The design was completed from the right side, using free machine embroidery and hand embroidery combined with beads and sequins. The fabrics included silk dupion and taffeta.

The design for the large panel is taken from a border in the *Book of Durrow* and uses hand dyed silk velvet for the main areas. Each segment was decorated in a different way; some have sheer fabric shapes applied by machine, others are hand stitched and include bead decoration. Most of the backing fabric was removed and replaced with a more transparent fabric. A few spiral and knot motifs were worked in sheer fabric with free machine embroidery applied along the edge of the design.

Quilting

Quilting is a form of needlework in which two or three layers of fabric are stitched together. In the most common form, a layer of padding is sandwiched between two layers of fine fabric. A very wide range of designs can be created using this kind of quilting.

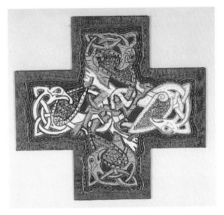

Fig 20.22 A complex, interwoven zoomorphic design

Fig 20.23 In this quilted cushion it is texture rather than colour that shows the pattern

Italian, or cord quilting, is a variation in which two layers are stitched together in patterns. This style requires parallel lines of stitching to form a channel through which a cord is threaded in order to raise parts of the design above the background. Because of this, it is particularly well suited to knotwork and spiral designs, which can be drafted directly onto the background fabric. However, it is essential to use a non-permanent method of transferring the design, as the most popular stitch for quilting is a small, running stitch, and any pencil marks, if not erasable, will show through.

Pastel drawing

When drawing this Yorkshire terrier, it was necessary to keep a balance between the desire to use as much detail as possible without compromising the object of the work, which was to develop the long hair into a spiral design.

Fig 20.24 This unusual use of spirals adds interest and texture to the drawing

Adapting curves and rounded corners

There are some crafts, popular examples including knitting and cross stitch, in which the curves of Celtic designs cannot be followed. For these, all the curves must be 'squared off'. A simple way to do this is to plot the design in pencil, with the curves, and then draw in angles and straight lines to replace the curves. Ink in this amended design and then rub out the pencilled curves. The resulting pattern can be transferred to the working piece as required. An example of a squared-off chart is given in Fig 20.25.

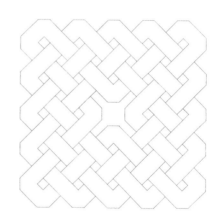

Fig 20.25 Straight lines and sharp corners produce a very strong design

About the Author

Brought up during the war when few toys were available, Sheila was kept entertained with paper. Her father encouraged her to draw intricate patterns and make paper toys, and introduced her to the basic principles of paper engineering – a pastime which has developed into a lifetime pleasure.

Sheila is interested in many crafts. She enjoys designing and making automata, moving toys and tatting shuttles, her collection of corn dollies and straw work is now on permanent display at Shuggborough Hall and she gives regular workshops in paper-related crafts for the County and Borough Councils. Her other interests include golf and playing the clarinet with a local concert band and has recently taken up the oboe. She is a Parish Council Clerk, qualified music teacher and, together with a friend, runs a book-keeping service for local traders.

This is Sheila's third book on Celtic design, following *Celtic Knotwork Designs* and *Celtic Knotwork Handbook*, also by GMC Publications.

Sheila lives in Lancashire with her husband and has three sons.

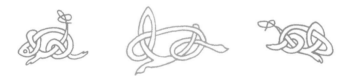

TITLES AVAILABLE FROM

GMC Publications

BOOKS

WOODCARVING

The Art of the Woodcarver *GMC Publications*
Carving Architectural Detail in Wood:
 The Classical Tradition *Frederick Wilbur*
Carving Birds & Beasts *GMC Publications*
Carving Nature:
 Wildlife Studies in Wood *Frank Fox-Wilson*
Carving on Turning . *Chris Pye*
Carving Realistic Birds *David Tippey*
Decorative Woodcarving *Jeremy Williams*
Elements of Woodcarving *Chris Pye*
Essential Tips for Woodcarvers *GMC Publications*
Essential Woodcarving Techniques *Dick Onians*
Further Useful Tips for Woodcarvers . . *GMC Publications*
Lettercarving in Wood: A Practical Course *Chris Pye*
Making & Using Working Drawings for
 Realistic Model Animals *Basil Fordham*
Power Tools for Woodcarving *David Tippey*
Practical Tips for Turners & Carvers . . *GMC Publications*
Relief Carving in Wood:
 A Practical Introduction *Chris Pye*
Understanding Woodcarving *GMC Publications*
Understanding Woodcarving
 in the Round *GMC Publications*
Useful Techniques for Woodcarvers . . *GMC Publications*
Wildfowl Carving – Volume 1 *Jim Pearce*
Wildfowl Carving – Volume 2 *Jim Pearce*
The Woodcarvers *GMC Publications*
Woodcarving: A Complete Course *Ron Butterfield*
Woodcarving: A Foundation Course *Zoë Gertner*
Woodcarving for Beginners *GMC Publications*
Woodcarving Tools &
 Equipment Test Reports *GMC Publications*
Woodcarving Tools, Materials & Equipment . . . *Chris Pye*

WOODTURNING

Adventures in Woodturning *David Springett*
Bert Marsh: Woodturner *Bert Marsh*
Bill Jones' Notes from the Turning Shop *Bill Jones*
Bill Jones' Further Notes from the Turning Shop . . *Bill Jones*
Bowl Turning Techniques Masterclass *Tony Boase*
Colouring Techniques for Woodturners *Jan Sanders*
The Craftsman Woodturner *Peter Child*
Decorative Techniques for Woodturners . . . *Hilary Bowen*
Faceplate Turning *GMC Publications*
Fun at the Lathe . *R.C. Bell*
Further Useful Tips for Woodturners . . *GMC Publications*
Illustrated Woodturning Techniques *John Hunnex*
Intermediate Woodturning Projects . . *GMC Publications*
Keith Rowley's Woodturning Projects *Keith Rowley*
Multi-Centre Woodturning *Ray Hopper*
Practical Tips for Turners & Carvers . . *GMC Publications*
Spindle Turning *GMC Publications*

Turning Green Wood *Michael O'Donnell*
Turning Miniatures in Wood *John Sainsbury*
Turning Pens and Pencils *Kip Christensen*
 & Rex Burningham
Turning Wooden Toys *Terry Lawrence*
Understanding Woodturning *Ann & Bob Phillips*
Useful Techniques for Woodturners . . . *GMC Publications*
Useful Woodturning Projects *GMC Publications*
Woodturning: Bowls, Platters, Hollow Forms, Vases, Vessels,
 Bottles, Flasks, Tankards, Plates *GMC Publications*
Woodturning: A Foundation Course
 (New Edition) . *Keith Rowley*
Woodturning: A Fresh Approach *Robert Chapman*
Woodturning: An Individual Approach *Dave Regester*
Woodturning: A Source Book of Shapes *John Hunnex*
Woodturning Jewellery *Hilary Bowen*
Woodturning Masterclass *Tony Boase*
Woodturning Techniques *GMC Publications*
Woodturning Tools & Equipment
 Test Reports *GMC Publications*
Woodturning Wizardry *David Springett*

WOODWORKING

Bird Boxes and Feeders for the Garden . . *Dave Mackenzie*
Complete Woodfinishing *Ian Hosker*
David Charlesworth's
 Furniture-Making Techniques *David Charlesworth*
Furniture & Cabinetmaking Projects . . . *GMC Publications*
Furniture-Making Projects for
 the Wood Craftsman *GMC Publications*
Furniture-Making Techniques
 for the Wood Craftsman *GMC Publications*
Furniture Projects . *Rod Wales*
Furniture Restoration (Practical Crafts) . . *Kevin Jan Bonner*
Furniture Restoration and Repair
 for Beginners *Kevin Jan Bonner*
Furniture Restoration Workshop *Kevin Jan Bonner*
Green Woodwork . *Mike Abbott*
Making & Modifying Woodworking Tools . . *Jim Kingshott*
Making Chairs and Tables *GMC Publications*
Making Classic English Furniture *Paul Richardson*
Making Fine Furniture *Tom Darby*
Making Little Boxes from Wood *John Bennett*
Making Shaker Furniture *Barry Jackson*
Making Woodwork Aids and Devices *Robert Wearing*
Minidrill: Fifteen Projects *John Everett*
Pine Furniture Projects for the Home *Dave Mackenzie*
Router Magic: Jigs, Fixtures and Tricks to Unleash your
 Router's Full Potential *Bill Hylton*
Routing for Beginners *Anthony Bailey*
Scrollsaw Pattern Book *John Everett*
The Scrollsaw: Twenty Projects *John Everett*
Sharpening: The Complete Guide *Jim Kingshott*

Pyrography Handbook (Practical Crafts) . . .*Stephen Poole*
Ribbons and Roses*Lee Lockheed*
Rosewindows for Quilters*Angela Besley*
Rubber Stamping with Other Crafts*Lynne Garner*
Sponge Painting .*Ann Rooney*
Tassel Making for Beginners*Enid Taylor*
Tatting Collage .*Lindsay Rogers*
Temari: A Traditional Japanese
 Embroidery Technique*Margaret Ludlow*
Theatre Models in Paper and Card*Robert Burgess*
Wool Embroidery and Design*Lee Lockheed*

GARDENING

Auriculas for Everyone: How to Grow and
 Show Perfect Plants*Mary Robinson*
Bird Boxes and Feeders for the Garden . .*Dave Mackenzie*
The Birdwatcher's Garden*Hazel & Pamela Johnson*
Companions to Clematis:
 Growing Clematis with Other Plants .*Marigold Badcock*
Creating Contrast with Dark Plants*Freya Martin*
Gardening with Wild Plants*Julian Slatcher*
Hardy Perennials: A Beginner's Guide*Eric Sawford*
The Living Tropical Greenhouse: Creating a Haven
 for Butterflies*John & Maureen Tampion*
Orchids are Easy: A Beginner's Guide to their
 Care and Cultivation*Tom Gilland*
Plants that Span the Seasons*Roger Wilson*

VIDEOS

Drop-in and Pinstuffed Seats*David James*
Stuffover Upholstery*David James*
Elliptical Turning*David Springett*
Woodturning Wizardry*David Springett*
Turning Between Centres: The Basics*Dennis White*
Turning Bowls .*Dennis White*

Boxes, Goblets and Screw Threads*Dennis White*
Novelties and Projects*Dennis White*
Classic Profiles .*Dennis White*
Twists and Advanced Turning*Dennis White*
Sharpening the Professional Way*Jim Kingshott*
Sharpening Turning & Carving Tools*Jim Kingshott*
Bowl Turning .*John Jordan*
Hollow Turning .*John Jordan*
Woodturning: A Foundation Course*Keith Rowley*
Carving a Figure: The Female Form*Ray Gonzalez*
The Router: A Beginner's Guide*Alan Goodsell*
The Scroll Saw: A Beginner's Guide*John Burke*

MAGAZINES

✦ WOODTURNING ✦ WOODCARVING
✦ FURNITURE & CABINETMAKING
✦ THE DOLLS' HOUSE MAGAZINE
✦ THE ROUTER ✦ THE SCROLLSAW
✦ BUSINESSMATTERS
✦ WATER GARDENING

The above represents a full list of all titles currently
published or scheduled to be published. All are available
direct from the Publishers or through bookshops,
newsagents and specialist retailers. To place an order,
or to obtain a complete catalogue, contact:

GMC Publications,
Castle Place, 166 High Street, Lewes,
East Sussex BN7 1XU, United Kingdom
Tel: 01273 488005 Fax: 01273 478606
Orders by credit card are accepted

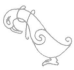